Images of America
IRISH CLEVELAND

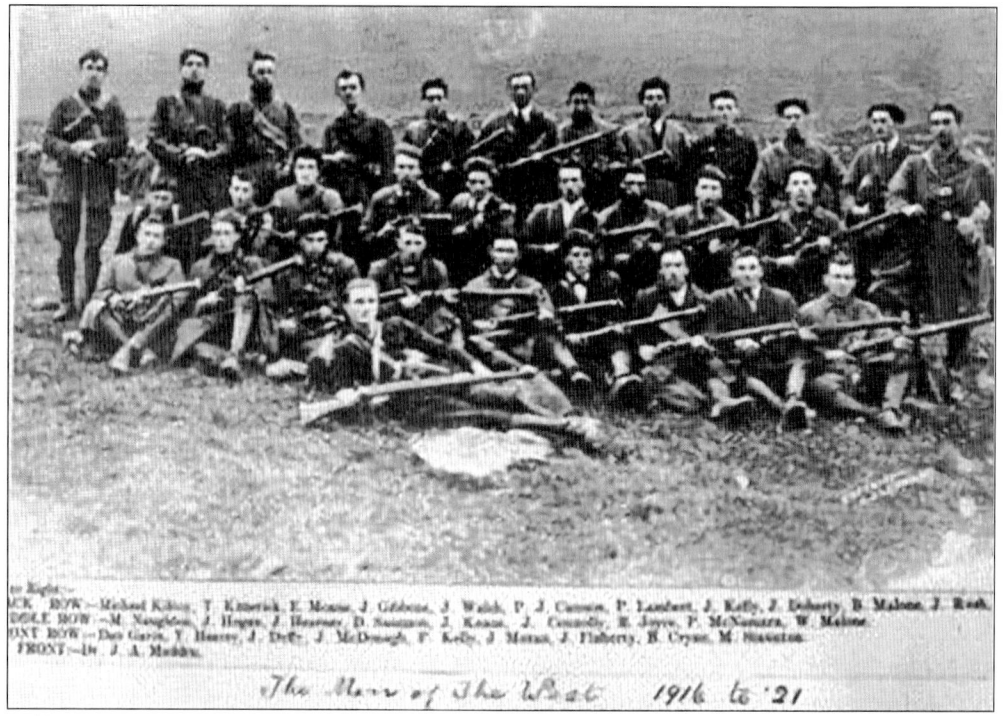

Kelly, Moran, Gibbons, Walsh, Keane, Sammon, Joyce, and McNamara are some of the names of "The Men of the West," a flying column from western County Mayo who served in the Irish Republican Army during the war of independence from 1916 through 1921. Most of these men have children, grandchildren, nieces, and nephews who make up the ranks of Irish Cleveland today. Erin Go Bragh (*Eirinn go Brach* in Irish), or "Ireland forever" in the English language. We honor the fighting spirit of the men and women who comprise the ranks of the Irish in America and the Irish in Cleveland. (Courtesy of the author.)

ON THE COVER: Five members of the West Side Irish American Club proudly carry their organization's banner as they march in the St. Patrick's Day Parade. The club banner is carried by, from left to right, Joe Patten, Mike McGinty, Bill O'Malley, and Pat O'Malley. They are followed by the uniformed honor guard, club president Gerry Lavelle, and vice president Terry Joyce, and Kathleen Lavelle Kloos leads the drill team. The photograph is dated 1978. (Courtesy of the Cleveland Public Library Photograph Collection.)

John Myers and Judith G. Cetina, PhD

Copyright © 2015 by John Myers, JD, and Judith G. Cetina, PhD
ISBN 978-1-4671-1349-6

Published by Arcadia Publishing
Charleston, South Carolina

Printed in the United States of America

Library of Congress Control Number: 2014947564

For all general information, please contact Arcadia Publishing:
Telephone 843-853-2070
Fax 843-853-0044
E-mail sales@arcadiapublishing.com
For customer service and orders:
Toll-Free 1-888-313-2665

Visit us on the Internet at www.arcadiapublishing.com

We are all immigrants,

Dedicated to our immigrant ancestors

THE EMIGRANT IRISH

They would have thrived on our necessities.
What they survived we could not even live.
By their lights now it is time to
imagine how they stood there, what they stood with,
that their possessions may become our power.

Cardboard. Iron. Their hardships parceled in them.
Patience. Fortitude. Long-suffering
in the bruise-colored dusk of the New World.

And all the old songs. And nothing to lose.

This portion of the poem "The Emigrant Irish" used with permission from author Eavan Boland, from *An Origin Like Water*. New York: WW Norton, 1997.

Contents

Acknowledgments		6
Introduction		7
1.	In the Beginning	9
2.	Under the Protection of Mother Church	21
3.	The Ties that Bind	39
4.	On St. Patrick's Day, Everyone Is Irish	57
5.	Those Who Serve	69
6.	Upstairs, Downstairs	79
7.	Sports Reign in Cleveland	97
8.	Nightlife and the Notorious	107
9.	Irish Ambassadors	117

Acknowledgments

The Cleveland area is blessed with several repositories that document and preserve the heritage of the area, and their holdings include a rich cache of photographs. We are indebted to Margaret Baughman—the photograph librarian for the Cleveland Public Library Photograph Collection—and her diligent staff for locating and retrieving images appropriate for this project. We also offer our gratitude to the Special Collections and Cleveland Press Collections of Cleveland State University's Michael Schwartz Library, with special thanks as well to Bill Barrow, special collections librarian, and Vern Morrison and Joanne Cornelius, of the Digital Production Unit. Also, many thanks to Phil Haas, of the Archives for the Diocese of Cleveland—who has been involved in our project almost from day one. Finally, our appreciation is extended to the Reverend Thomas D. Mahoney, who has freely shared his knowledge of the Irish community in Cleveland, both sacred and secular.

The photographs used in this text are, unless otherwise noted, from the Cleveland Public Library Photograph Collection (CPL), the Special Collections and Cleveland Press Collection of the Michael Schwartz Library (Cleveland Memory), the Archives for the Diocese of Cleveland (Diocese), and the author's personal collection (Author).

INTRODUCTION

With a population of 1.2 million people, Cuyahoga County has one of the richest and most diverse ethnic communities in the United States. Almost 500,000 residents of Northeastern Ohio can claim Irish ancestry, and the Irish American community can be seen as one of the major—and most active—cultural groups in Cleveland, Ohio. Visible proof of this can be seen in the annual St. Patrick Day's parade, on March 17, which represents the largest single-day event in the state of Ohio each year. The Irish take this celebration of faith and heritage seriously, and the parade normally has over 125 marching units, with 10,000-plus participants in spite of the low temperatures and snowy conditions typical to mid-March in Cleveland. For nearly 150 years, the parade has represented a shared, unifying experience for the Cleveland Irish and their non-Irish friends. Cleveland's Irish men and women are happy to share the ways that their families honor the holy day—whether by beginning the day attending Mass or other family traditions.

While Moses Cleaveland, who was on a surveying expedition for the Connecticut Land Company in 1796, was not Irish, the Irish were in the area before him. In the mid-1700s—decades before Cleaveland arrived—an Irish-born fur trader, George Croghan, established a post at the mouth of the Cuyahoga River, and in 1760, Robert Rogers and his Rangers mediated a treaty with Chief Pontiac in the same area. Mary Campbell, who was Irish, the first European child in the Western Reserve, was on the banks of the river near Cuyahoga Falls, where she lived with her Native American captors around 1760–1764. At the dawn of the 19th century, Commodore Oliver Hazard Perry—whose mother was born in Ireland—defeated the British at the Battle of Lake Erie on September 10, 1813, during the War of 1812. Alfred Kelly, who the Irish in Columbus, Ohio, have claimed as a son of Erin, played a pivotal role in the history of Cleveland, serving as the first county prosecutor and president of the village. More significantly, Kelley served as the father of the Ohio and Erie Canal, designating Cleveland as the canal's northern terminus and paving the way for Irish immigrants to come to Cleveland and work on the canal, put down roots, and participate in the development of a burgeoning commercial port.

In the years that followed, the Irish would load and unload cargo on the docks, seek jobs in the shipbuilding industry, join the safety forces in large numbers, assume leadership positions in the commerce and labor movements, and see members of their number elected as Cleveland's mayor, county commissioners, judges, state representatives, and members of Congress. The city's location on the shores of Lake Erie and the Cuyahoga River, and its designation as the canal terminus, made Cleveland an ideal place for the shipment of natural resources, including coal from southern Ohio and iron ore from the northern Great Lakes. Companies like Corrigan and McKinney would seize upon this opportunity and become a leading steel manufacturer. Even Cleveland's most famous son, John Davison Rockefeller, had roots in the Emerald Isle.

Numerous Irish clubs, civic organizations, and institutions have represented and served the city and the county, including the Ancient Order of Hibernians, the United Irish Societies, Clan na Gael, Irish Northern Aid, the Fenians, the Irish Benevolent Society, the Pioneer Total Abstinence

Society, the Gaelic Athletic Association, the Greater Cleveland Feis Society, the East and West Side Irish American Clubs, the Irish American Archives Society, the Ladies Ancient Order of Hibernians, the Mayo Society of Greater Cleveland, and the Padraic Pearse Center—to name only a few. The Irish have also built beautiful sacred structures as places of worship, with an Irish clergy to shepherd this immigrant flock.

Cleveland's Irish would also become world ambassadors for the city. Sr. Ignatia Gavin, CSA, worked with Bill Wilson and Dr. Bob Smith to create the internationally recognized group Alcoholics Anonymous, and part of East Twenty-second Street has been dedicated as Sr. Ignatia Way in her honor. Other Irish Clevelanders have also graced the international stage, including Johnny Kilbane, who became the world featherweight boxing champion in 1912 and held the title until 1923. The Irish sense of humor has been expressed through the comedy of Drew Carey, Tim Conway, and Jack Riley, and the reputation of the Irish as gifted communicators has been reflected through innovative television talk show hosts like Phil Donahue and Mike Douglas. There have been, however, other, more notorious characters. Gang warfare has resulted in the destruction of property and the loss of human life, with groups like the McCart, Blinky Morgan, and Cheyenne Gangs terrorizing west side Irish neighborhoods during the late 19th and early 20th centuries. Further, Tommy McGinty, a promising boxer in the stable of Jimmy Dunn—Johnny Kilbane's trainer—became a fight promoter and the owner of the Desert Inn in Las Vegas. He owned and operated a cheat spot on West Twenty-fifth Street and the Mounds Club, which catered to a higher class of customers, on Chardon Road in Lake County. He took the skills learned on the streets of Irish Cleveland and opened the legendary Desert Inn with Moe Dalitz. He would later be nicknamed "Black Jack" McGinty.

This brief introduction cannot do justice to the remarkable history of the Irish in Cleveland, and many worthy men and women, outstanding institutions and organizations, and important milestones are yet to be considered. It would take several books to fully illustrate the richness of Irish life in Cleveland, but the following chapters should provide an overview of this rich mosaic. It is hoped that this book will introduce the reader to many of the organizations and people of Irish Cleveland, and that it might spur continued research and new publications about the fascinating story of these people. Please feel free to share your comments and critiques via email to irishcleveland@gmail.com, or follow on twitter with #irishcleveland.

We would like to further acknowledge the work of Fr. Nelson Callahan and William Hickey and direct those readers so motivated to learn more about the subject to their seminal work *Irish Americans and Their Communities of Cleveland* (1978), which is out of print but can be found on line at the Cleveland Memory Project: www.clevelandmemory.org. See also www.eastsideirish.org.

Also, Judge Sean Gallagher's detailed history of the West Side Irish American Club, *Volunteers*, can be found at the club's web site: www.WSIA-Club.org. Author John O'Brien Jr.'s work, *Festival Legends: Songs and Stories*, tells the rich history of Irish music, which room did not permit to give its proper due; it can be found at www.songsandstories.net. O'Brien is also the publisher of the monthly *Ohio Irish American News*. Moreover, Irish Clevelanders Debbie and Dan Hanson created www.clevelandpeople.com to document Cleveland's rich ethnic heritage, but we know their first love is Cleveland's Irish community. And also turn to the Irish American Archives Society's web site for a great collection of material telling the stories of Irish Cleveland: www.irisharchives.org. George Condon's books are a rich source of information on the Irish Cleveland community.

For topical and current sharing of Irish music and news of the Cleveland Irish, join one of the dozens and dozens of Irish social and cultural groups referenced in this book.

Cleveland's Irish community is fortunate to have several weekly radio shows to keep the Irish community entertained and up to date:
WKTL FM 90.7, *Johnson Bros. Radio Hour*, Saturday, 10:00–11:00 a.m.
WCSB FM 89.3, *Sweeney Astray with Bill Kennedy*, Sunday, 7:00–9:00 a.m.
WHK AM 1420, *Jerry Quinn's Irish Hours*, Sunday, 10:00a.m.–noon
WCWA AM 1230, *Echoes of Ireland with John Connolly*, Sunday, 1:00–3:00 p.m.
WRUW FM 91.1, *Beyond the Pale with Roger Weist*, Sunday, 4:00–6:00 p.m.

One

IN THE BEGINNING

Recent research suggests that the Irish may have arrived in the Americas before Italian explorer Christopher Columbus, establishing a settlement in what is now South Carolina. Further, some have asserted that St. Brendan may have been the first Irishman and European to reach North America, on his fabled sixth-century voyage to the Isle of the Blessed. Historical documentation shows that between 50,000 and 100,000 Irish came to the United States during the 17th century, with an additional 100,000 arrivals in the 1700s. The Irish population would grow exponentially, and, by 2010, the census would record 39 million Irish Americans in the United States. Irish settlement in Northeastern Ohio, however, began more modestly in the early 19th century. One chronicler of Cleveland history reports that a schooner reached Cleveland in 1818 bearing six Irish families, while a 1903 presentation to the Early Settlers Association featured a litany of Irish surnames, representing Irish immigrants to Cleveland from 1830 to 1849 and including the Cahills, Farleys, Gallaghers, McCarts, Smiths, and Whelans.

The 1820s saw a larger Irish presence, as men emerged from their work on the Erie Canal—connecting the Hudson River with Lake Erie at Buffalo—and came to Cleveland to seek employment on the Ohio Canal—connecting Lake Erie to the Ohio River. Afterwards, some remained in the village of Cleveland, seeking jobs as dockworkers. Shunned by the local citizenry and caught in the grip of poverty, they made a home in the least desirable location available—the swamplands (the Flats) adjacent to the Cuyahoga River that included Whiskey Island, the Angle, and Irish Town Bend. The name Whiskey Island is attributed to the fact that early settler Lorenzo Carter kept his still there, though the later Irish settlement there may have added to the title.

In 1825, the Irish community's population was considered sufficient for the Catholic Church to send a resident priest to Cleveland. The church would become an anchor for a largely Roman Catholic community, and, by 1900, there were 12 parishes serving the needs of Irish Catholics.

After the Canal Irish, the next wave to come to Cleveland was the Famine Irish. The Irish Cleveland community honored this time with a monument on the banks of the Cuyahoga River.

The Great Hunger Memorial reads:

> The Great Hunger / An Gorta Mor / Ireland's Potato Famine 1845–50 This memorial commemorates the passing of 150 years since the misery known as "The Great Hunger" A carnage visited upon the Irish nation diminishing her population by millions as a result of imposed political and economic structures, many of the Irish were driven to the potato alone for survival. Consequently, Ireland's people starved to death or were forced to emigrate. Many dying on "Coffin Ships" en route. This is one of the most tragic and significant events in Irish history.
> Lest we forget: To those who died, to those who came and enriched our Cleveland shores. We dedicate this monument to you.
> Erected on the anniversary of the 'Great Hunger' by the Greater Cleveland Irish Community in the year of our Lord 2000.

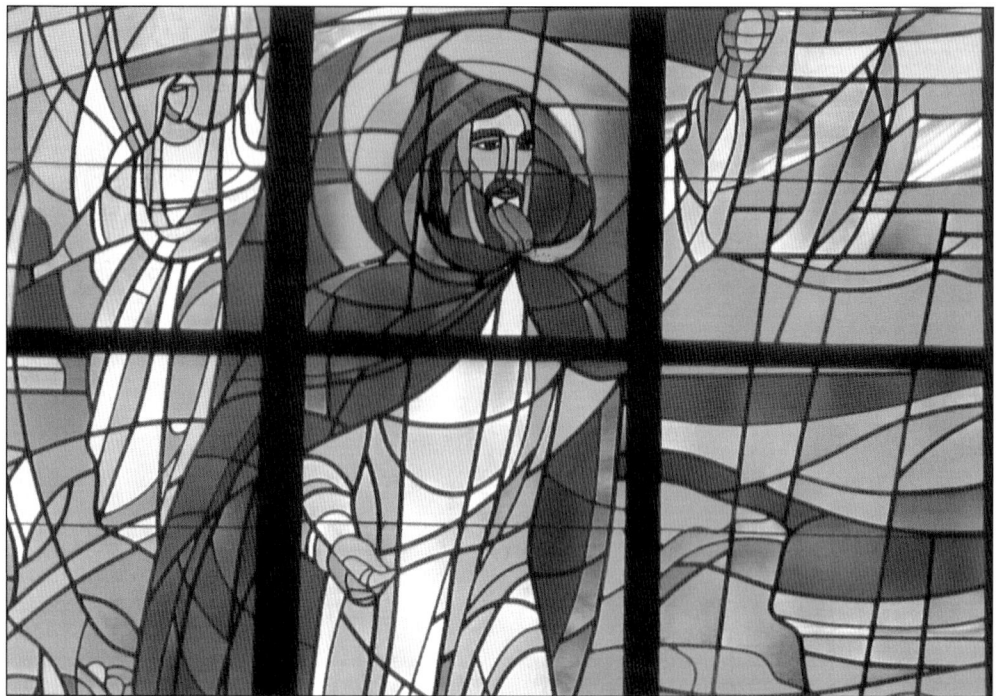

St. Brendan the Navigator was one of the early Irish monastic saints, served as the bishop of County Kerry, and is largely remembered for his sixth century quest to find the Isle of the Blessed. The St. Brendan Society has done extensive scholarly work asserting Brendan was the first European to reach North America, arriving nearly a millennium before Columbus. This stained-glass depiction of Brendan is located at St. Brendan Parish in North Olmsted. In 1964, Archbishop Edward Hoban named Fr. John Kenny, a native of County Leitrim, Ireland, as the parish's founding pastor. (Author.)

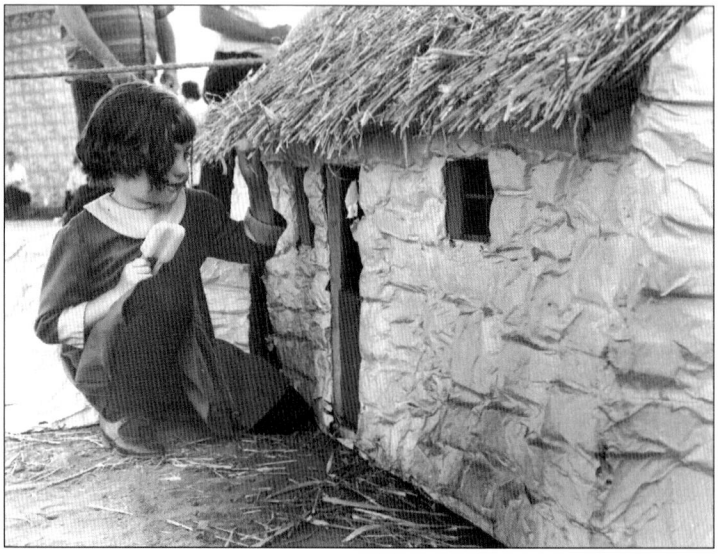

Many Irish immigrants left homes like this miniature model of John F. Kennedy's family dwelling, which was built for the St. Patrick's Day parade in 1964 and served as one of the major attractions at that year's Irish Cultural Festival. The daughters of Mrs. Edward McDonnell of Chicago, Joyce and Patricia, joined others in viewing this miniature. (CPL.)

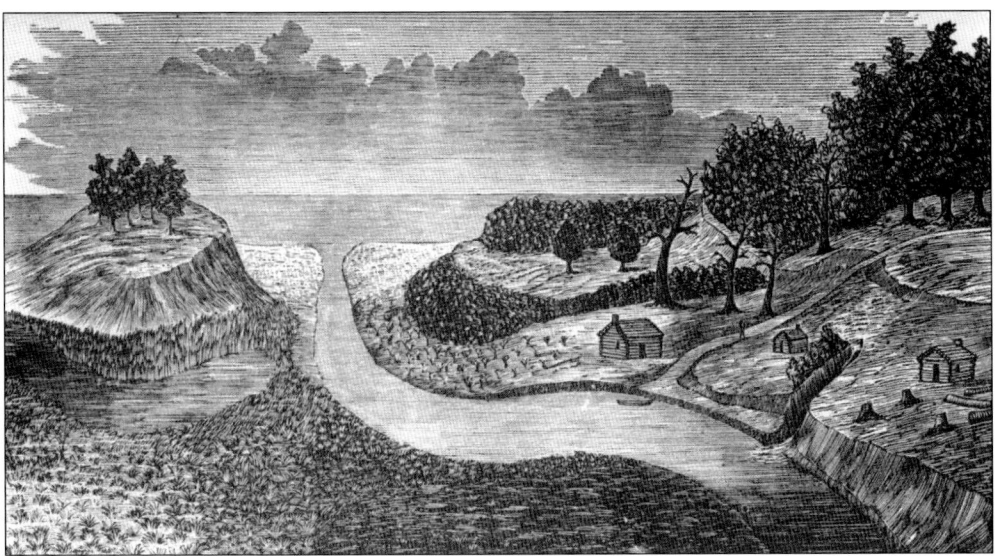

This simple woodcut image depicts Cleveland in 1800, showing buildings that include a surveyor's cabin, a log warehouse, and Lorenzo Carter's first cabin. George Croghan, an Irish-born fur trader, wintered in a primarily Seneca village at the mouth of the Cuyahoga River—also seen in this artist's rendering—that preceded Carter's arrival. (CPL.)

Charles Yardley Turner's painting *Conclave Between Rogers Rangers and Chief Pontiac at the Cuyahoga River, November 1760* is on display in the Cuyahoga County Courthouse. Documentation shows that Robert Rogers, who led the Rangers, was the grandson of Jacob Rogers, of Dublin, Ireland, and the son of James Jacob Rogers, of Derry, Ireland. (CPL.)

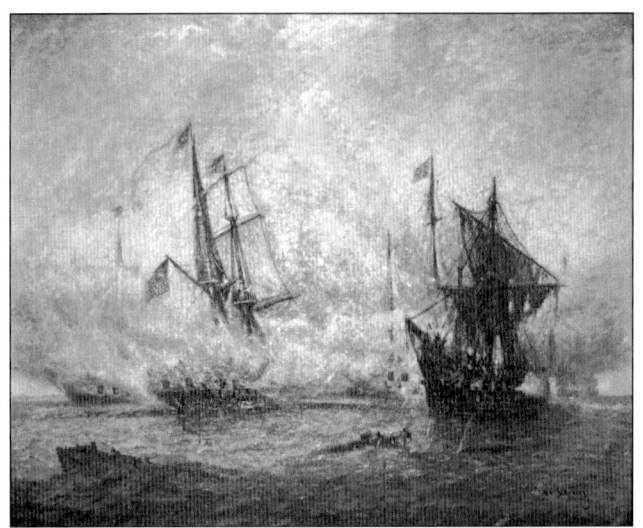

Commodore Oliver Hazard Perry dealt the British a crucial blow at the Battle of Lake Erie during the War of 1812. This painting is the work of Orlando Schubert and commemorates the 100th anniversary of the battle. Commodore Perry's Irish roots came from his mother, Sarah Wallace Alexander, who was born in Loughbrickland, in County Down, Ireland. She married Christopher Raymond Perry in Rhode Island. (Courtesy of the Cuyahoga County Archives.)

Although Commodore Perry was not native to Cleveland, the city adopted him as a war hero who helped to secure peace so that Cleveland might flourish. This statue of Perry was dedicated on Cleveland's Public Square in 1860. The statue was moved multiple times but found a permanent home in 1991 at Fort Huntington Park, adjacent to the current Cuyahoga County Courthouse. The Battle of Lake Erie was the only time in the history of the British Navy that an entire British fleet was captured. (CPL.)

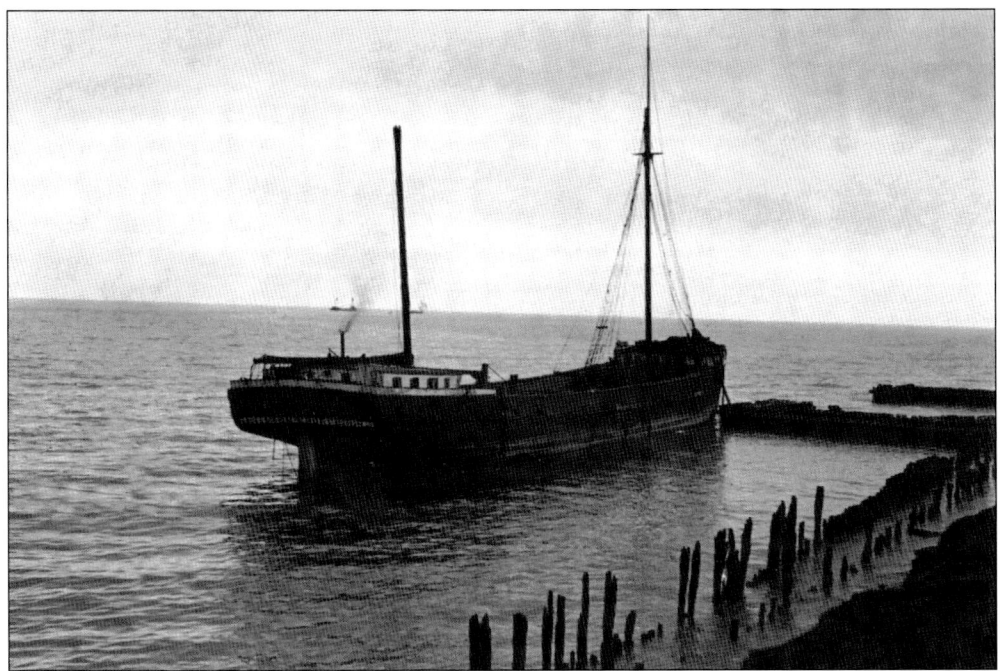

Author William G. Rose notes that, on June 22, 1818, the schooner *American Eagle* arrived in Cleveland from Buffalo, carrying six families of Irish—comprised of 47 passengers who were three months out from Ireland. Although no image of the *American Eagle* could be found, this wooden schooner, photographed in 1908, is similar to the original vessel. (CPL.)

Cleveland fronts on Lake Erie, part of the largest body of fresh water in the world. The presence of this vital natural resource, in concert with the mighty Cuyahoga River, nurtured the growth of Cleveland and facilitated manufacturing, trade, and transportation. Its primary gift to the Irish was jobs as canal diggers, dockworkers, ship builders, and steel makers. (CPL.)

The Erie Street Cemetery, on East Ninth Street, opened in 1826 and was the first burial ground for the early Irish settlers. The names of some of the Irish buried there before 1840 are William Delaney, Dennis Reardon, C. McShane, and Stephen Monahan. The oldest Catholic cemetery was St. Joseph's, on Woodland Avenue, which opened in 1849 and was followed by St. John's Cemetery in 1858, also on Woodland Avenue. (CPL.)

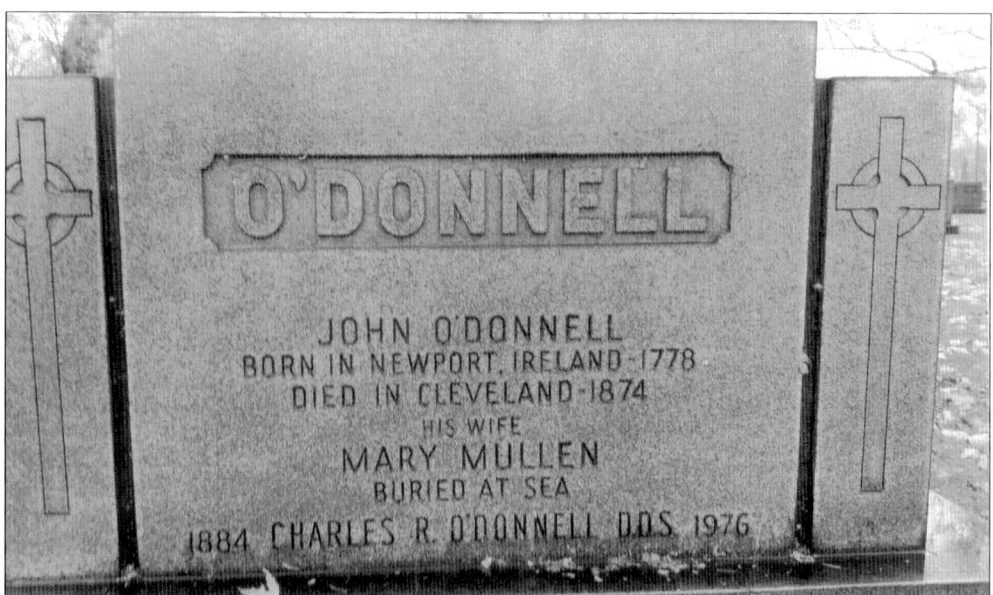

This headstone documents the story of the O'Donnell family, which began in Ireland and ended in St. John's Cemetery. Note that Mary Mullen, the wife of John O'Donnell, never arrived on America's shores, a common occurrence on transatlantic voyages. More than 28 members of the Cleveland O'Donnell family are buried here, including Kevin O'Donnell, who served as director of the Peace Corps and president of SIFCO Industries. (Author.)

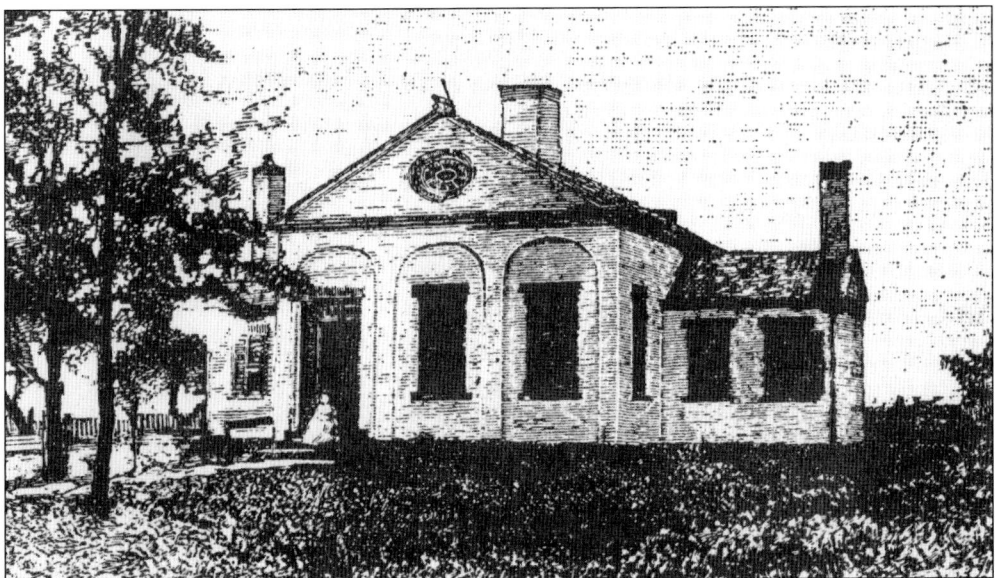

Alfred Kelley was dubbed the "Father of the Ohio and Erie Canal" and served as both county prosecutor and president of the village of Cleveland. The coming of the canal to northern Ohio—with Cleveland as its northern terminus—encouraged the migration of Irish workers to Cleveland in search of work and a place to call home. Although Kelley's Irish roots have not been documented, the surname is one common to Ireland, and the Irish are happy to claim him. (Cleveland Memory.)

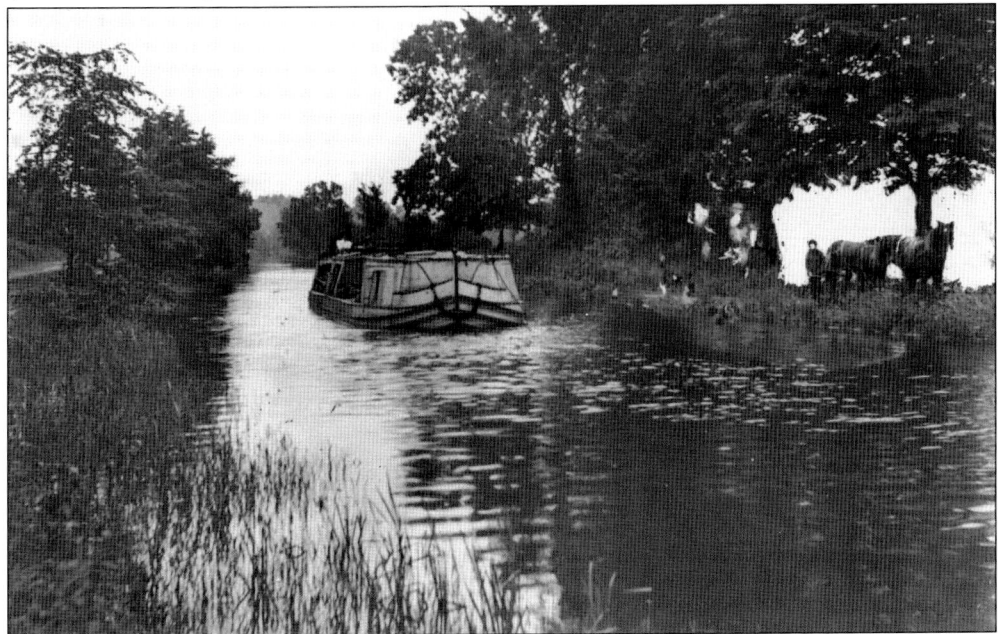

This 1894 photograph of a canal boat on the Ohio and Erie Canal was taken south of the five-mile lock, located near the Austin Powder Company, in what was once Newburgh Township. The canal was primarily constructed by Irish workers for a wage of 30¢ per day, as well as board, lodging in camps, and a daily ration of whiskey, which helped them deal with dysentery and long, grueling days. The canal was also known as the Irish Ditch. (CPL.)

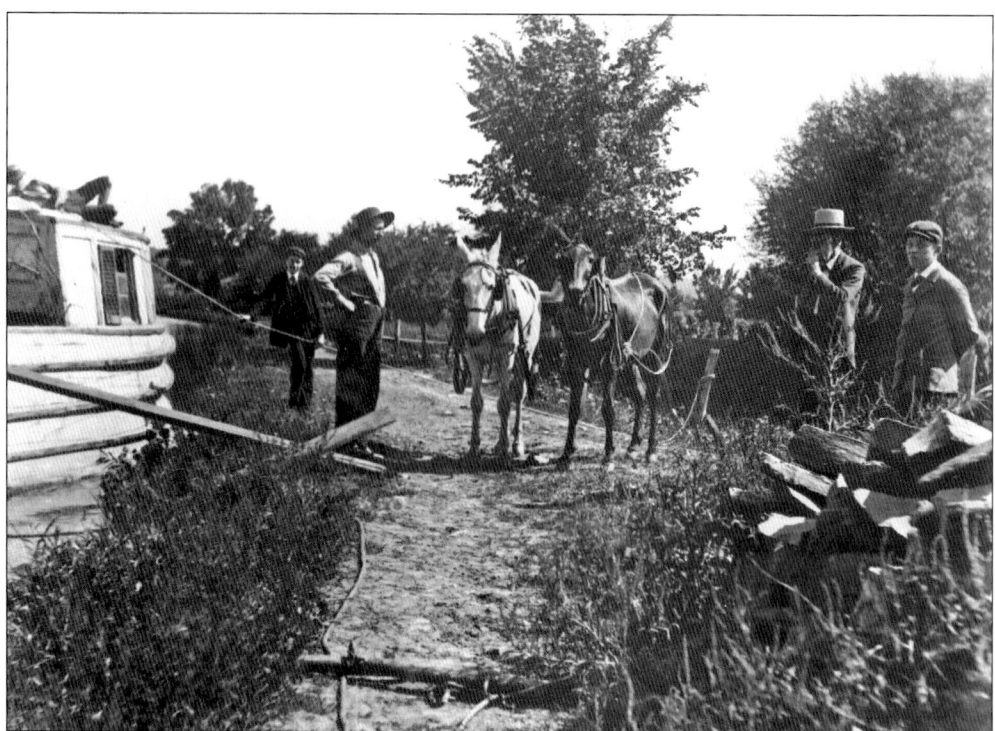

The canal that the Irish built was no longer in its heyday by the end of the 19th century, and this photograph displays an old canal boat and a well-worn towpath. Four gentleman and two horses stand witness to the end of the canal system as the primary means of transport. The railroad, which also employed many Irish, became the preferred mode of transportation starting in the 1850s. (CPL.)

Canal building was dangerous work, and many Irish perished due to the minimal safeguards in place to ensure their well-being. For example, Patrick Shiels fell to his death off a wall under a building on Superior Street, where he was engaged in digging the canal. He was single and 34 years of age. Malarial fever and dysentery were common scourges of the canal worker. (CPL.)

Whiskey Island was the first piece of solid land found among the swamps along the Cuyahoga River when Moses Cleaveland arrived in 1796. Among the employees of the Connecticut Land Company was a Joseph McIntyre—perhaps another early Irish arrival. Irish immigrants largely came to Whiskey Island during the construction of the canal and the rechanneling of the Cuyahoga River. Initially, they lived in temporary shacks or lean-tos, but after investors bought the Carter farm in 1831, allotments were created along 22 streets. Manufacturing plants and docks were later constructed. In this 1931 image, a man, who might have been a canal worker 100 years earlier, is seen eating his lunch on Whiskey Island. (CPL.)

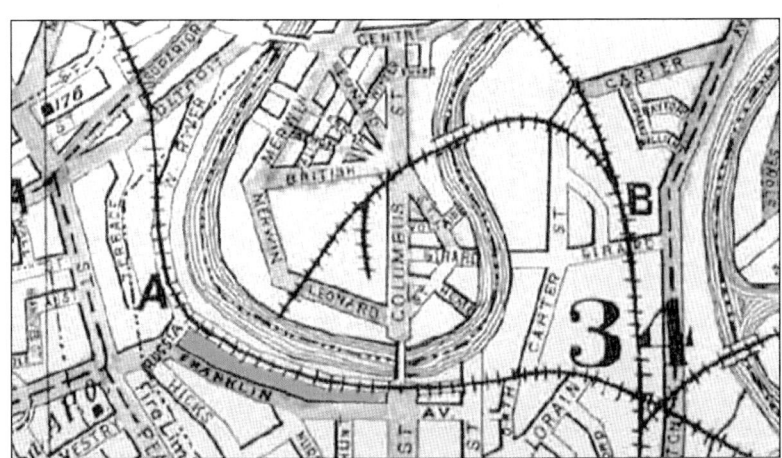

This small section from the 1892 atlas of Cuyahoga County, including the city of Cleveland, clearly illustrates the location of Irishtown Bend. It extended roughly from West Twenty-fifth Street east to the river and south of Detroit Avenue. (CPL.)

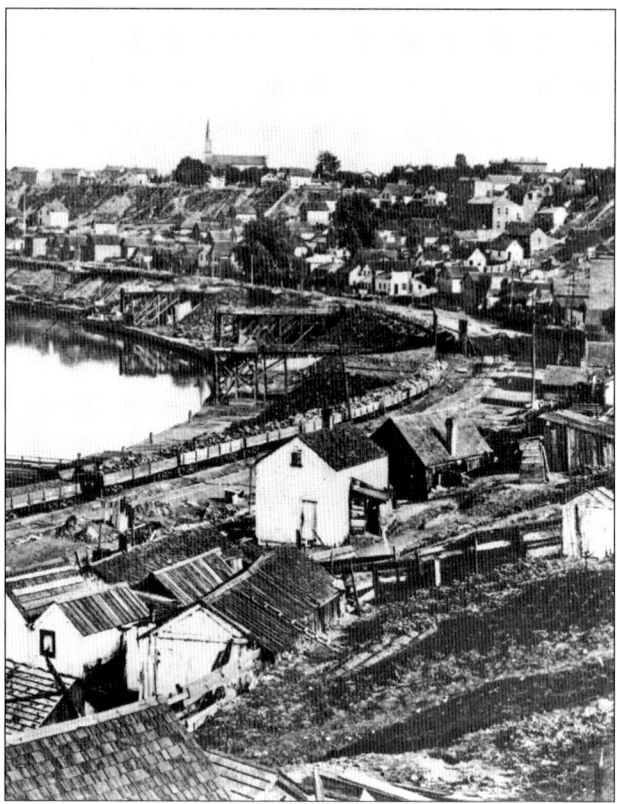

Many Irish gradually moved further away from the river, taking up residence in what was known as Ohio City. Both Cleveland and Ohio City were incorporated in 1836, and Ohio City was annexed to Cleveland in 1854. This maps provides a detailed view of the two municipalities on both sides of the Cuyahoga, as well as Whiskey Island. (CPL.)

As Cleveland's Irish population grew, some moved away from Whiskey Island (right) and took up residence on the west side of the Cuyahoga River Bluffs, creating a community of tar paper shacks known as Irishtown Bend—adjacent to today's Franklin Road hill east of West Twenty-fifth Street. This photograph, dated 1885, illustrates the poverty of the area. (CPL.)

The sun illuminates Winslow Avenue, in the Angle, on an afternoon in 1947. From a distance, it appears that the benches are being used by older residents who are dressed in their Sunday best. (CPL.)

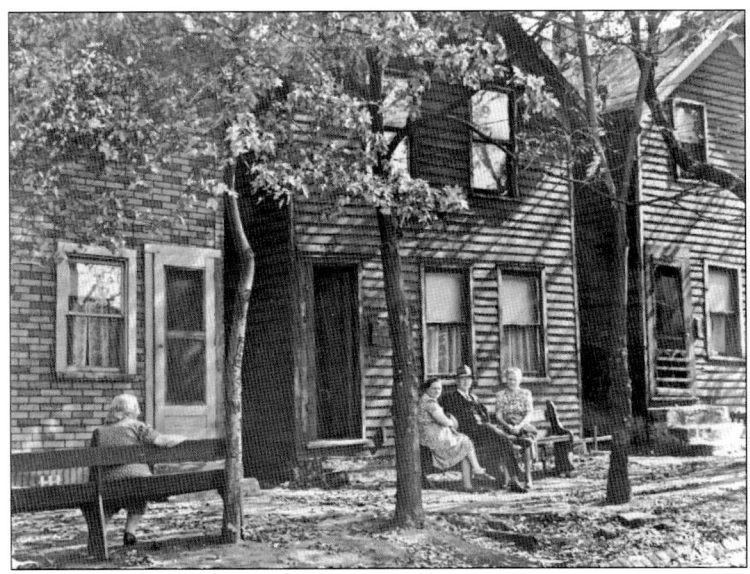

This 1937 aerial view of the old riverbed at Whiskey Island reveals an industrial hub with river traffic, railroad tracks, and smoke billowing from nearby industries. It is quite a contrast from the depths of the swampland, where many Irish fell victim to malaria-bearing mosquitoes in the 1800s. Many jobs, all within walking distance of Ohio City, the Angle, and Irishtown Bend, are represented in the photograph. (Cleveland Memory.)

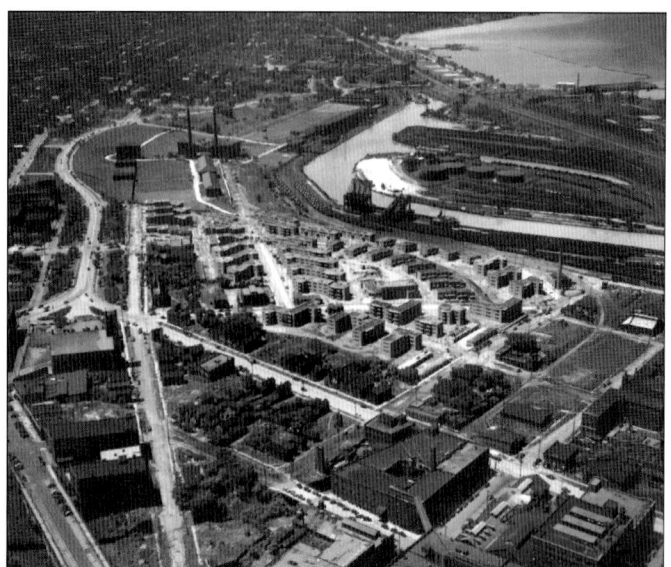

The Lakeview Terrace public housing development was one of three in Cleveland, which were the first to be authorized by the federal government. It has been suggested that this landmark complex contributed to the end of a significant Irish neighborhood known as the Angle—a triangle formed by West Twenty-eighth Street, Division Avenue, and the Cuyahoga River bed. This 1930s photograph provides an aerial view of Lakeview Terrace two years after its completion. (Cleveland Memory.)

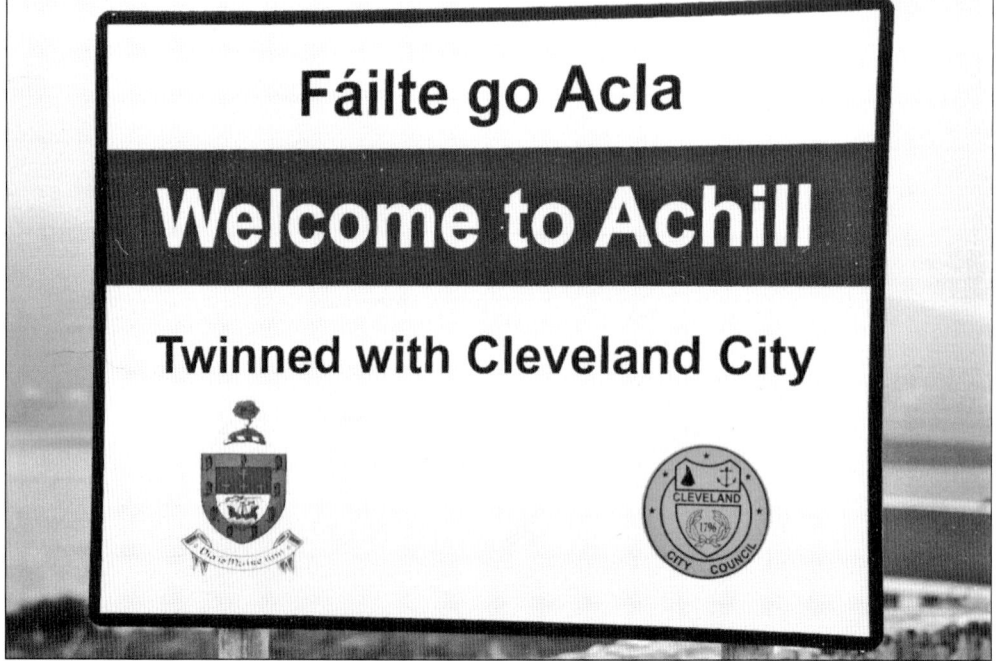

The "twinning" or sister-city relationship initiated by Mayor Jane Campbell, the Cleveland City Council, and the Mayo County Council with Achill Island, County Mayo, in 2003 symbolized Cleveland's long and strong relationship with not only Achill Island and County Mayo but with Ireland in general. These official acts were a dream of Steve Mulloy, a native of Achill who worked with fellow Achill Islander and Clevelander Con Mangan and his wife, Kathleen, a native of Newport, and many others in town to make this happen. In Ireland, Terrence Dever, Councilor Pat Kilbane, Mayo Council president Frank Chambers, and a cast of supporters on the ground welcomed a delegation from Cleveland and showed them true welcome, hospitality, and friendship. On the banks of the Cuyahoga, at the Irish Heritage Site (IHS) next to the Great Hunger Memorial, stands a rock memorializing this twinning. (Author.)

Two

UNDER THE PROTECTION OF MOTHER CHURCH

The completion of the Ohio and Erie Canal ushered in a prosperous commercial era for Cleveland, with the population soaring from 1,900 in 1833 to 14,000 by 1848. Nearly 50 percent of Cleveland's residents were not born in the United States, and nearly all of the Irish were Roman Catholic. It became a necessity to provide a Catholic church and a pastoral shepherd, and Bishop John Baptist Purcell of Cincinnati—originally from County Cork, Ireland—chose Irish-born John Dillon as the first resident Catholic pastor in Cleveland. Father Dillon, who arrived in Cleveland in 1835, became an indefatigable champion for the construction of a church building, and although he died from a fever while raising subscriptions for this structure, his dream would be realized when the first Mass was said at St. Mary on the Flats in October 1839. Other Irish priests would succeed Father Dillon as pastor, beginning with Fr. Patrick O'Dwyer and, eventually, Frs. Peter McLaughlin, Maurice Howard, and Michael A. Byrne. St. Mary on the Flats was soon found insufficient to accommodate the growing flock, and Father McLaughlin purchased lots adjacent to Erie Street (now East Ninth Street) to create a better location for his parish. Amadeus Rappe, bishop of the newly formed Diocese of Cleveland, would act upon McLaughlin's intuitive purchase, using the land as the site for the Cathedral of St. John the Evangelist, dedicated in 1852.

Between 1835 and 1900, an additional 12 parishes were established in areas where the Irish played a dominant role. As the Irish moved up from the Flats and settled in new neighborhoods, parishes were established for four predominantly Irish communities on Cleveland's near west side: St. Patrick's Church, St. Malachi, St. Augustine, and St. Colman. Cleveland's east side Irish would find their spiritual homes on Superior Avenue, St. Clair Avenue, and St. Catherine's Street, in Immaculate Conception, St. Bridget, St. Columbkille's Parish, St. Aloysius, St. Thomas Aquinas, and St. Catherine. Further, Holy Name was established in 1854 to serve the first Catholics to settle in Newburgh. Each parish established its own parochial school—a place of instruction in faith and academics that, with the church, formed a social, cultural, and spiritual center for the Irish community. Despite the importance of the church, the Irish identity would be also be forged through social, cultural, and political organizations.

In this 1935 photograph, Fr. John F. Mulholland points to a four-foot model of Our Lady of the Lake Church—more commonly known as St. Mary on the Flats. It was the first permanent Roman Catholic church constructed in Cleveland and was dedicated on June 4, 1840. This site was on the Cuyahoga River, just east of the current Columbus Street lift bridge. The land was donated by several prominent Protestant Clevelanders. (CPL.)

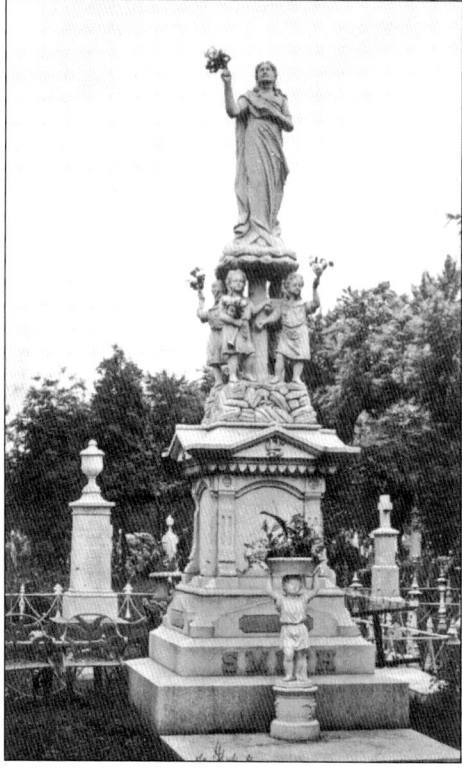

Father Dillon, from County Limerick, was appointed as the first pastor of Cleveland. Serving a largely Irish and German Catholic community, Dillon worked hard to raise funds for the planned church but died of a fever resulting from his efforts. Although originally buried in Erie Street Cemetery, and later the cathedral's crypt, Father Dillon's final resting place was St. John's Cemetery, seen here, on Woodland Avenue. (CPL.)

Shortly after the establishment of the Diocese of Cleveland in 1848, a St. Patrick's Church was established in Rockport Township for an Irish and German farming congregation. The fifth-grade class depicted here, with teacher Penny Robinson at right, attended the school nearly 100 years later. St. Patrick's on Bridge Avenue was formed in 1853. (Cleveland Memory.)

The growth of the Roman Catholic community necessitated the addition of new parishes, and, consequently, led the poor Irish of the Flats out of the lowlands. Missionary Fr. James Conlan was appointed as the pastor of the new St. Patrick's Parish in 1853. The cornerstone for the current church was laid in 1871. St. Patrick–Bridge is considered the mother church of Cleveland's Irish community. (Cleveland Memory.)

St. Augustine Parish was created in 1860 to serve the growing spiritual needs of Irish Catholics on Cleveland's near south side (Tremont). It remained a mission of the diocese until 1867, when the community received its first pastor—who also built the rectory and school. The first- and second-grade classes in this photograph attended the St. Augustine school in the 1890s. (Diocese.)

St. Malachi Church, founded in 1865, was intended for the Irish immigrants from the neighborhood known as the Old Angle. It was referred to as the "port" church, and the steeple's cross was lighted at night to guide ships to safe harbor. As this photograph dramatically documents, the church was ablaze in 1943, with streams of water directed at the burning building. Rising from the ashes, a new church was built and dedicated in 1947, fronting on West Twenty-fifth Street. St. Malachy was the first native Irishman to be canonized and served as the Bishop of Armagh. (CPL.)

St. Mary on the Flats soon proved too small to meet the needs of a burgeoning Roman Catholic community, so the new Cathedral of St. John the Evangelist was built east of the Cuyahoga River on land purchased by St. Mary's pastor, Fr. Peter McLaughlin. Completed in 1852, the cathedral was not only the site of the bishop's chair but served as an active parish and educated boys and girls in two separate schools. (CPL.)

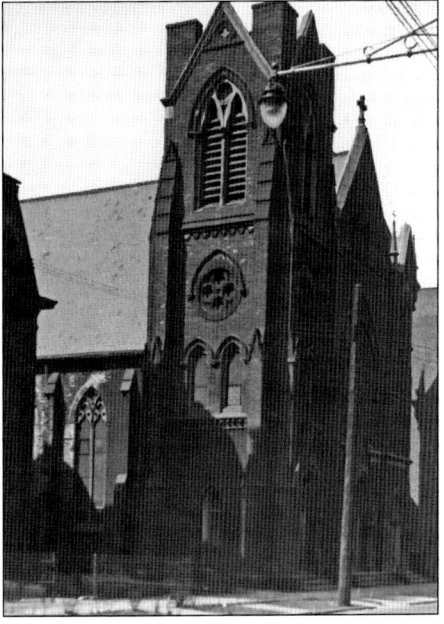

The community of Irish Catholics living in the area of Perry Street and Woodland Avenue had to travel some distance to attend Mass at St. John's Cathedral. They were eventually successful in establishing their own church and parish, and the parishioners of St. Bridget celebrated the Christmas of 1857 with their first Mass. In 1876, Pastor William McMahon undertook the major construction of a new church. Eventually, in 1938, social and economic changes in the area led to the merger of St. Bridget Church with the parish of St. Anthony's, both now closed. (CPL.)

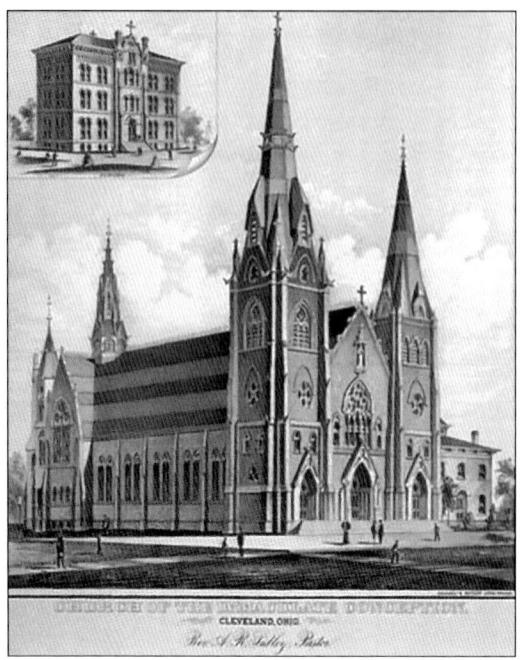

The Church of the Immaculate Conception—affectionately known as "the Mac"—is located at East Forty-first Street and Superior Avenue and was built to serve a predominantly Irish neighborhood in 1865. Frs. F. Sullivan and A.M. Martin were two of the first priests to serve this community. This was the home parish of Sr. Ignatia Gavin, and it is reported that guns were stored under the floorboards of the Mac for the Fenian invasion of Canada in 1866. (Cleveland Memory.)

In 1902, Bishop Ignatius Horstmann called for the formation of a parish on the west end of Lorain Street, which led to the establishment of St. Ignatius of Antioch Church, on Lorain Avenue at West Boulevard. In this photograph, parishioners have gathered on Thanksgiving morning in 1957 for the blessing of a marble statue of St. Ignatius by Msgr. A.J. Murphy. (CPL.)

The Irish population on the near west side continued to flourish, and the opening of St. Colman's Church—under the leadership of Pastor Eugene M. O'Callaghan—was celebrated in July 1880. The community initially met for Mass in an empty schoolhouse on Pear Street, and the church, with an interior that represented the Irish heritage of many parishioners, was dedicated in 1918. It continues to serve the people of the neighborhood on West Sixty-fifth Street, near Madison Avenue. St. Colman, who was born in the Irish province of Connacht around 605, became a bishop and was the founder of the Diocese of Mayo. In 2014, Pastor Bob Begin retired after 20 years of ministry. (CPL.)

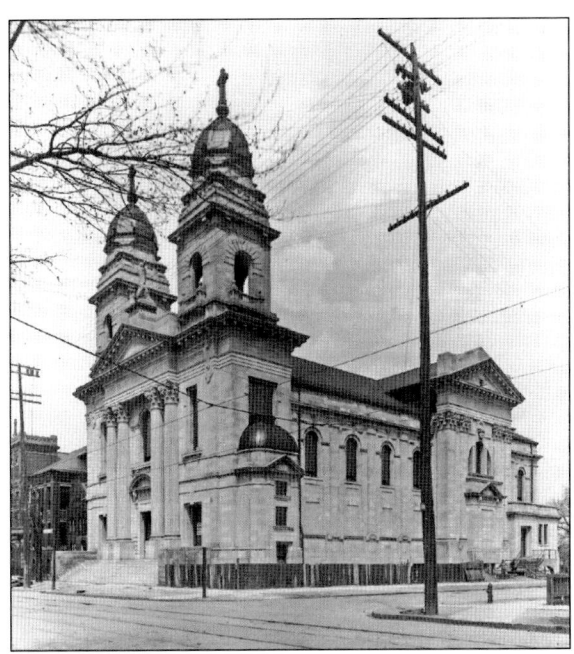

A school is integral to parish life and the Irish American tradition, and it is the institution where youths can both receive a solid education and mature spiritually. By 1889, St. Colman's had secured space, and, in 1904, a brick building with 12 classrooms had been erected. In this photograph, teacher Karen Joyce leads a class in morning prayer. (Cleveland Memory.)

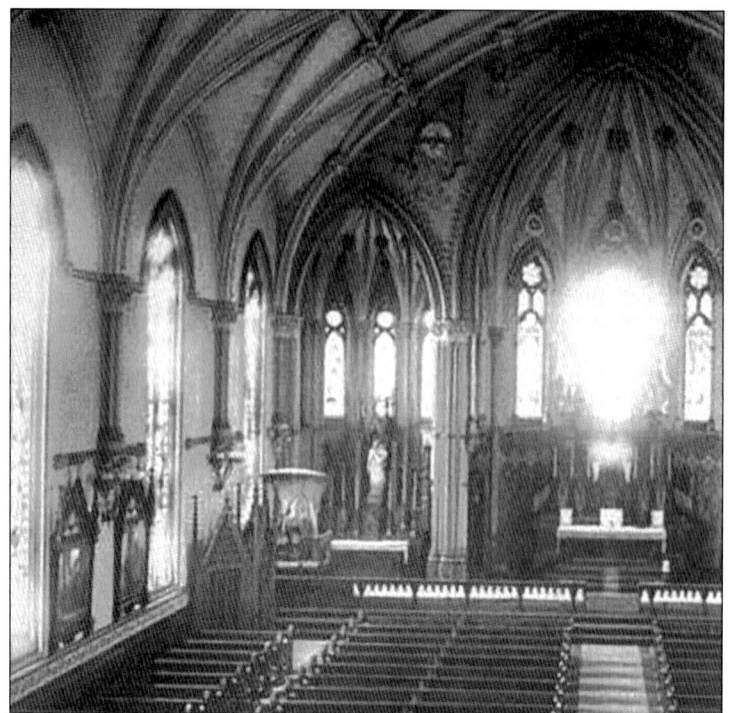

Established in the 1850s, Holy Name was one of the earliest parishes in Cleveland—serving the growing number of Irish in the village of Newburgh, where the steel mill was employing thousands. In 1914, Holy Name High School was opened at the Broadway Avenue parish, and it continues to operate today at its campus in Parma Heights. (Cleveland Memory.)

A group of concerned widows petitioned the diocese to see to the welfare of the expanding Irish and German populations in the Hough area, and in 1893, St. Agnes Church was established at 8100 Euclid Avenue as a response to their plea. The beautiful interior of this house of worship can only be seen through photographs, as the church was razed in 1975 and all that remains is the bell tower next to the current CVS pharmacy. St. Agnes merged with Our Lady of Fatima in 1980, and this parish continues to serve the needs of its community. (Diocese.)

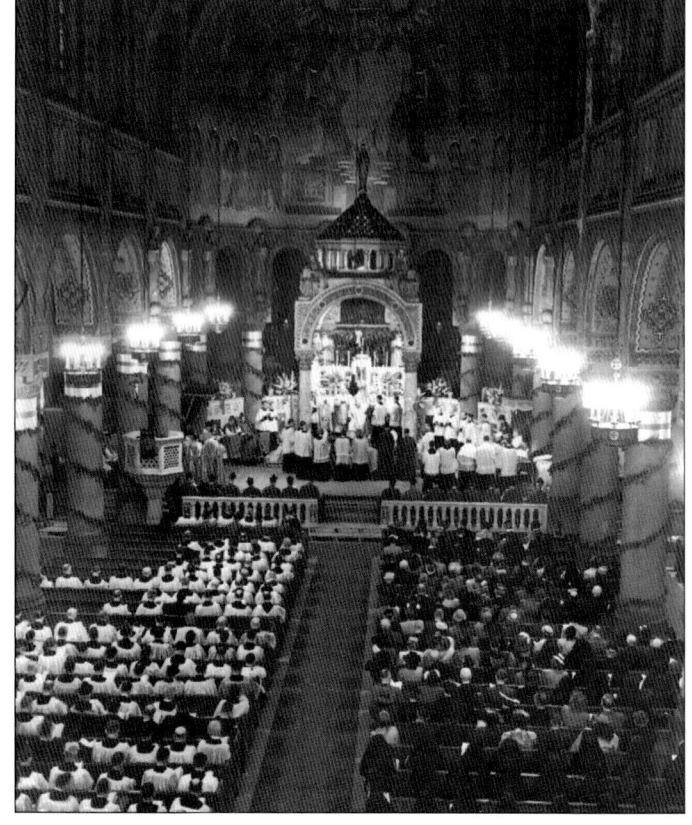

St. Ann Church was established in Cleveland Heights in 1915, under the leadership of its dynamic pastor, Fr. John Mary Powers. The temporary church was completed in only three months, and the first liturgy was a Midnight Mass, delivered by Rev. Dr. William Scullen. There was a distinct Irish presence in the opening liturgy, including altar servers William A. Sweeney and William Hogan. Rev. Dr. Joseph Nolan celebrated a second Mass. The church in the photograph was not completed until 1952. (Courtesy of Communion of Saints Parish.)

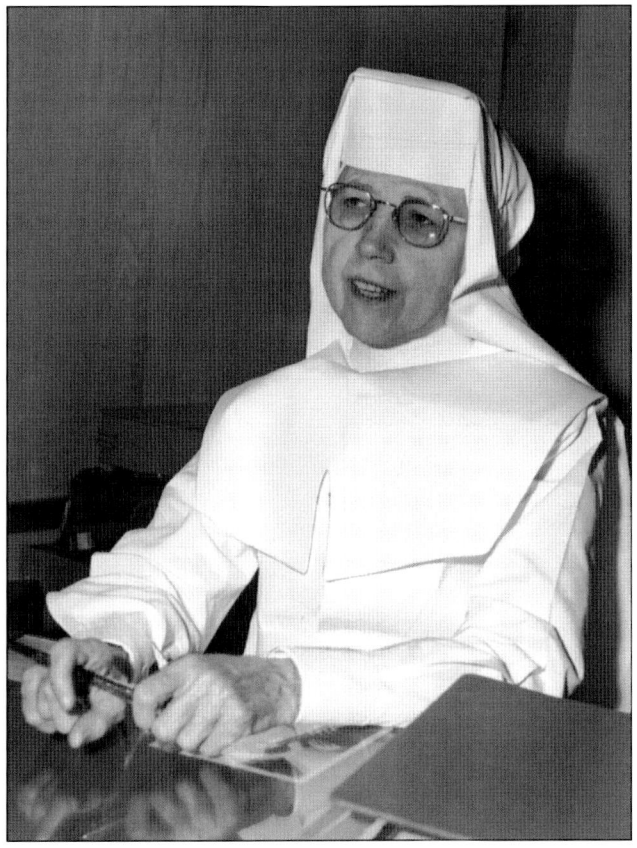

From the secular to the sacred, Clevelanders remember Delia Gavin—an Irish immigrant who came to Cleveland and entered the Sisters of Charity of St. Augustine in 1914. Better known as Sister Ignatia, her ministry centered on health care, and she was also an accomplished musician. Sister Ignatia, Bill Wilson, and Dr. Bob Smith later made a significant contribution to the treatment of alcoholism by founding the now worldwide Alcoholics Anonymous in northern Ohio. (Cleveland Memory.)

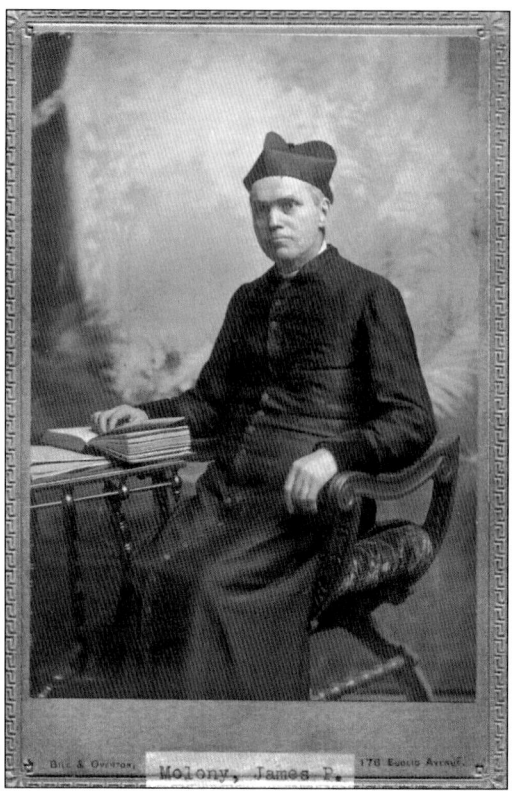

Priests native to Ireland were frequently sent to lead parishes that served largely Irish communities. Appointed by Bishop Amadeus Rappe, Fr. James Molony shepherded St. Malachi Parish—serving at a new church located north and east of St. Patrick (Bridge Avenue). He remained pastor from 1865 until his death in 1903, and many regarded him as a saint in their community. (Diocese.)

A contemporary of Father Maloney, James Conlon was sent to serve as pastor of St. Patrick on Bridge Avenue by Bishop Rappe. It appears that he viewed this community of faith as an Irish parish from the outset and supported the preservation of Irish culture. A quiet man, he nevertheless encouraged the formation of a tightly knit Irish Catholic parish, which appeared to some to be proud and independent. Conlon died in Charity Hospital in 1875, having spent 22 years as St. Patrick's pastor. Since then, the parish has been served by the Marists and the Jesuits, and it is currently under the spiritual leadership of Fr. Mark Di Nardo, who has been pastor since 1980. It is reported that the wooden pillars at St. Patrick–Bridge were secured from the Cunard Line from the masts of the immigrant ships. (Diocese.)

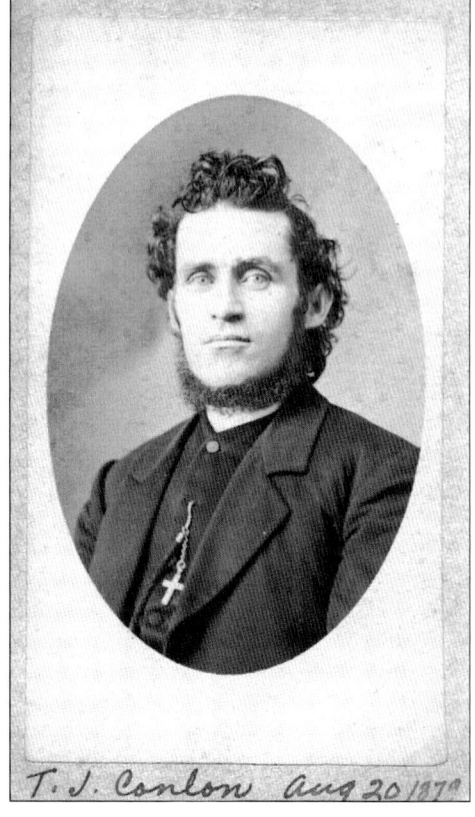

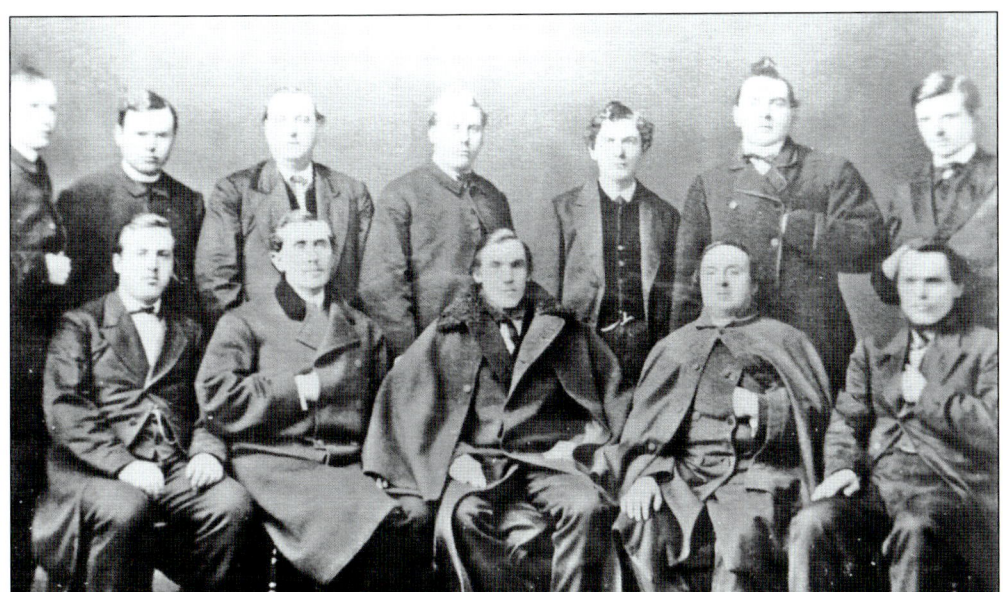

Photographed during the winter of 1871, this august group of gentlemen represents the Irish-born priests of the Diocese of Cleveland. These "Twelve Apostles" were missionaries for the church, serving in Cleveland, Grafton, Norwalk, Sandusky, and Youngstown. Many of them are buried in St. John's Cemetery on Woodland Avenue. (Diocese.)

The man pictured here had the distinction of being one of several Catholic priests with the surname Gallagher. Perhaps what distinguished him from the others was Fr. Hugh Gallagher's service during World War II, for which he received multiple medals. Father Gallagher devised a system that transferred surplus food from the troops to malnourished German children, and he was nicknamed "Uncle Von America." In 1950, he returned to Cleveland after a year's service as a chaplain in Alaska, having been named a lieutenant colonel in the Air Force. (Diocese.)

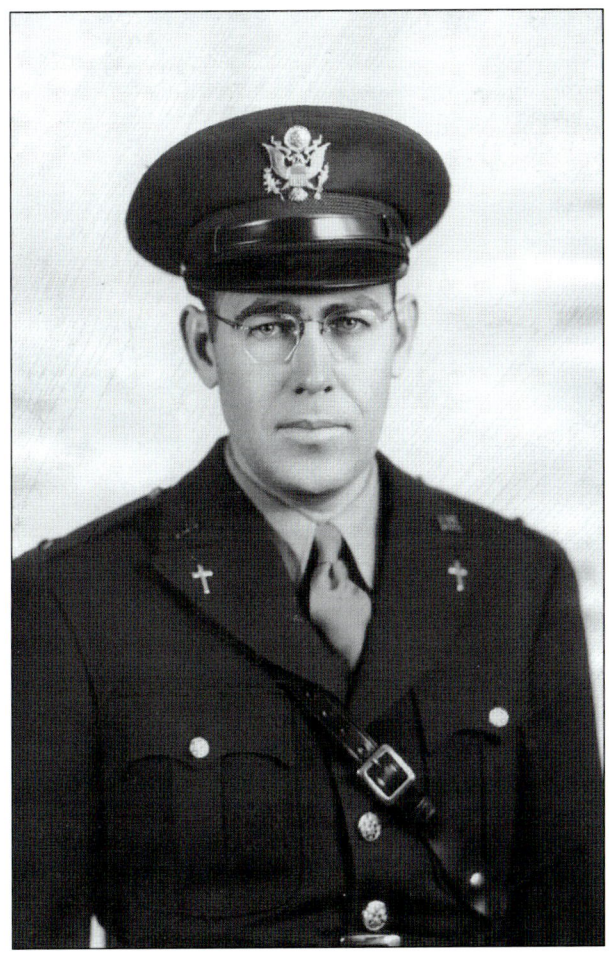

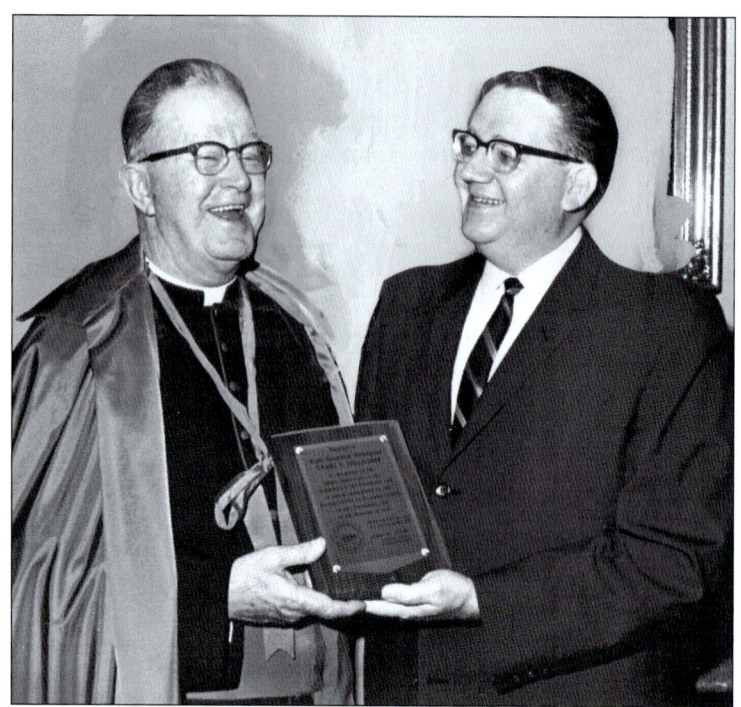

Another of the priests with the surname Gallagher was Daniel T. Gallagher, monsignor of St. James Church in Lakewood. The monsignor was responsible for the lovely artwork in the church, as well as some of the beautiful stone pillars, which may date back to ancient Rome and Greece. Gallagher (left) and Robert Lawther, the mayor of Lakewood, are holding a plaque and smiling cordially. (Cleveland Memory.)

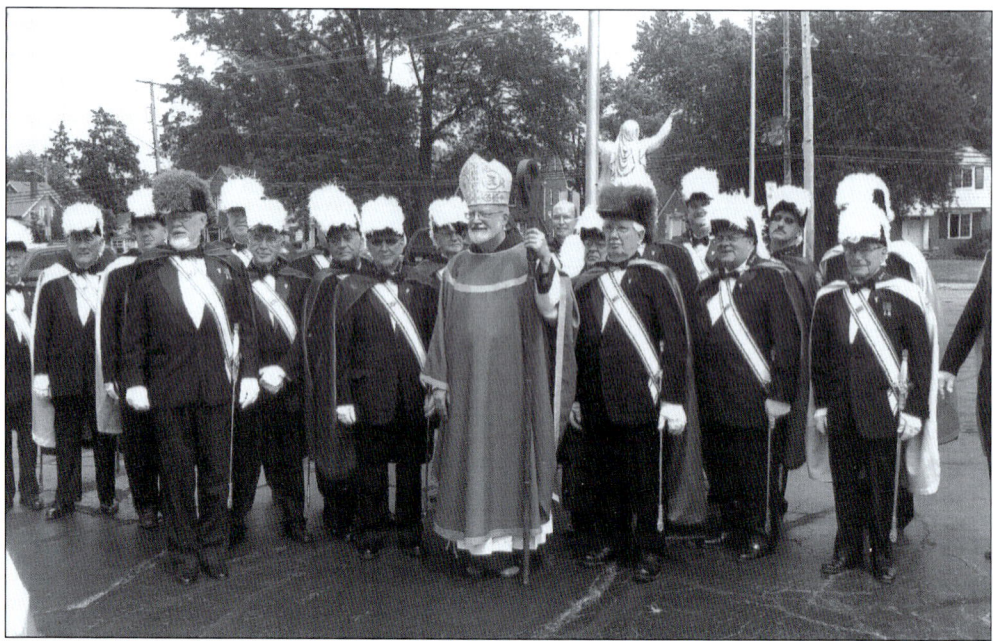

In 2012, the Knights of Columbus served as an honor guard to welcome Cardinal Sean O'Malley back to Cleveland. O'Malley served in Boston but was born in Lakewood, Ohio, and lived on Waterbury Avenue. Cardinal O'Malley came to celebrate—along with the Poor Clares and his fellow Franciscans—the 800th anniversary of St. Clare's canonization and the foundation of the order. Years earlier, Cardinal O'Malley had celebrated his first Mass with the Poor Clares, who arrived in Cleveland in 1877 and established their monastery on Rocky River Drive in the West Park neighborhood. (Author.)

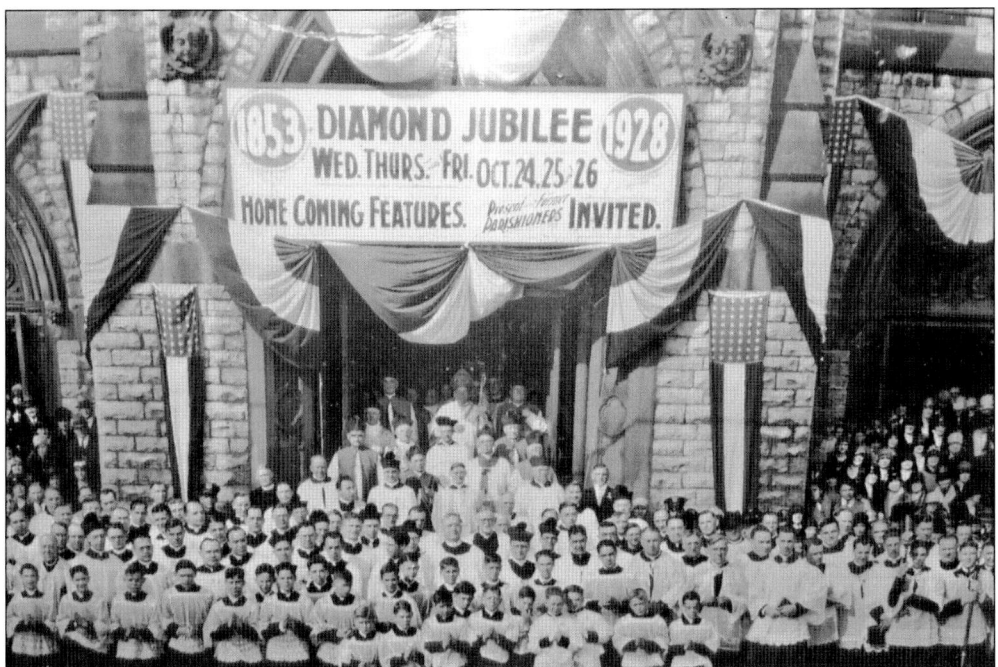

St. Patrick's Church on Bridge Avenue, the mother parish of Cleveland's Irish community, celebrated the diamond anniversary of its establishment in 1928. As the banner suggests, former and present parishioners were invited as part of a homecoming for the community. (Courtesy of St. Patrick's Parish.)

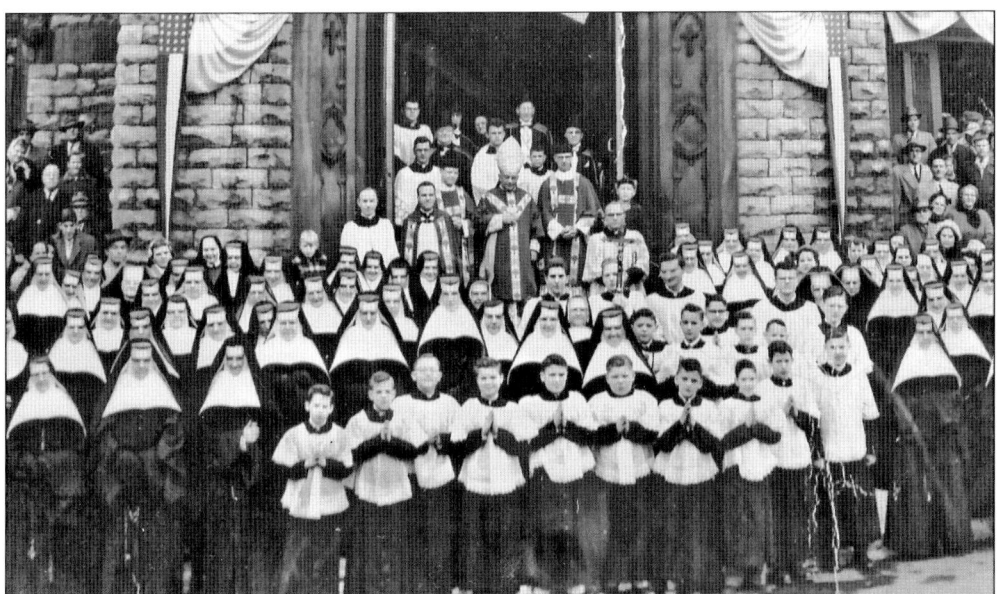

Parishioners of St. Patrick–Bridge Avenue gather to celebrate the parish's centennial in November 1953. It was reported that St. Patrick's grade school was the largest parochial school in the nation. (Courtesy of St. Patrick's Parish.)

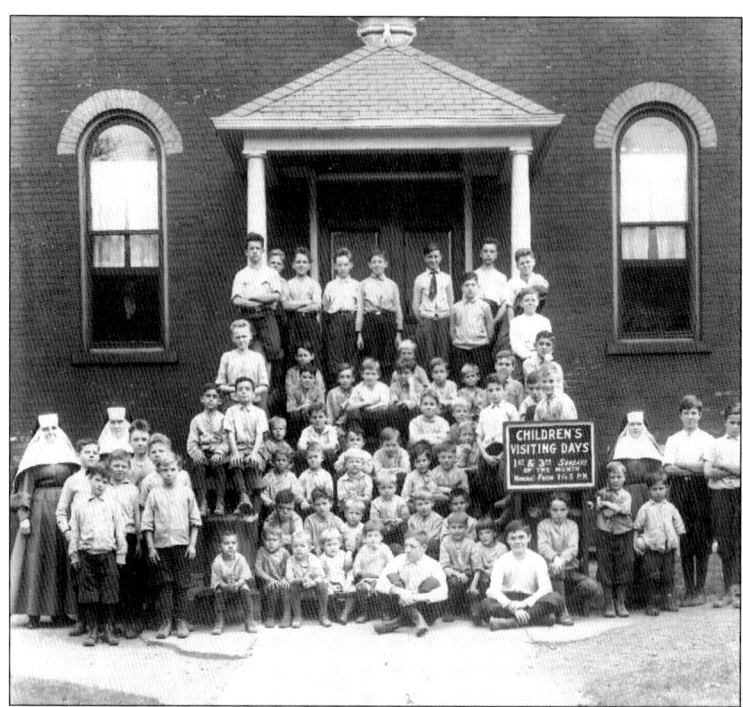

The young men photographed here represent only a fraction of the 250 boys housed at St. Vincent's Orphanage. It is clear from the sign that visiting days were limited to the first and third Sundays of the month, from 1:00 to 5:00 p.m. The Sisters of Charity served as a watchful presence for their charges, one of the many ministries of their order. (Diocese.)

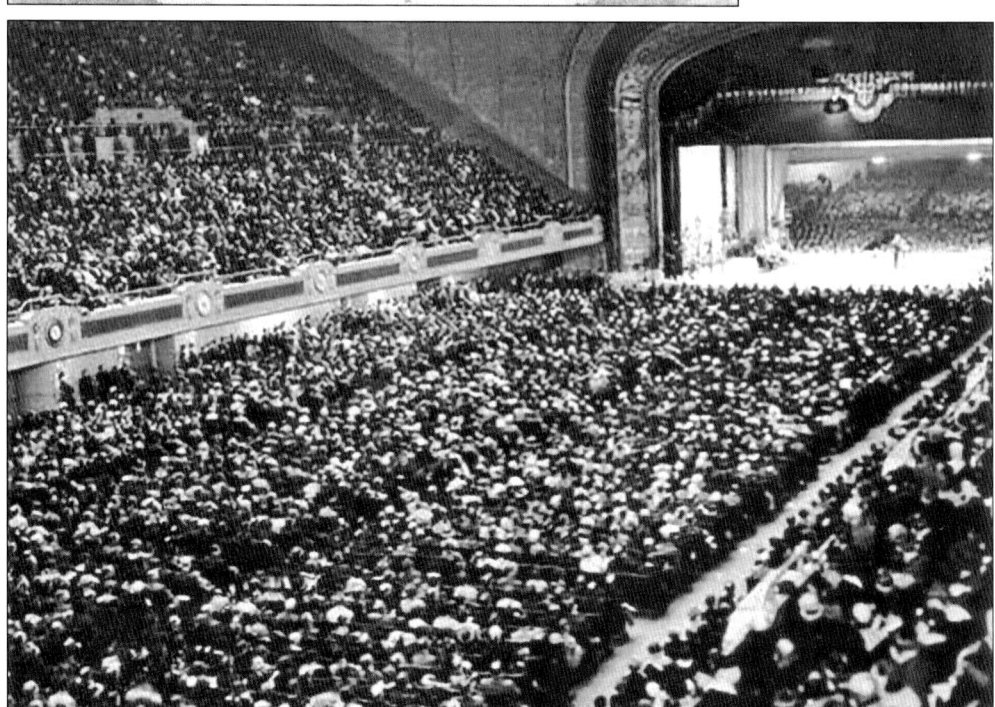

In 1935, a crowd of 30,000 filled Cleveland's Public Hall to hear the Radio Priest, Fr. Charles Coughlin, address a rally of the National Union of Social Justice. Coughlin was one of the most influential voices of the 1930s and, though his speeches became increasingly controversial as World War II approached, his broader message of social justice and economic reform appealed to many Depression-era Irish Clevelanders. (CPL.)

Cardinal Patrick Hayes was archbishop of New York from 1919 until his death in 1938. He was born in New York City to parents from County Kerry, Ireland. In this photograph, taken on September 24, 1935, Hayes blesses a crowd from a car as he travels down Euclid Avenue during the National Eucharistic Congress. (CPL.)

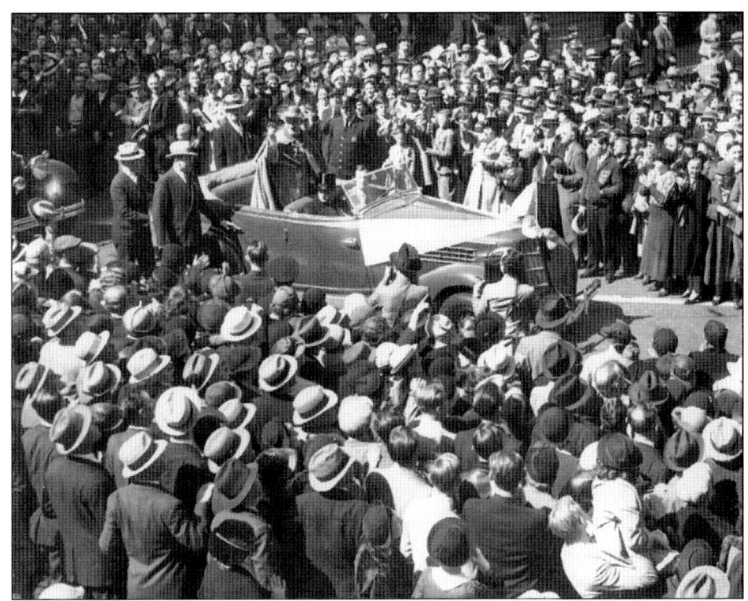

Al Smith was the first Roman Catholic to run for the presidency but was defeated by Herbert Hoover in 1928. Smith's maternal grandparents were from Ireland, and he identified with the Irish American community and became its spokesman. In this photograph, taken at the National Eucharistic Congress in Cleveland, he is giving a crowd a warm greeting with his wife, Catherine Ann Dunn, whose parents were from County Westmeath, Ireland. (CPL.)

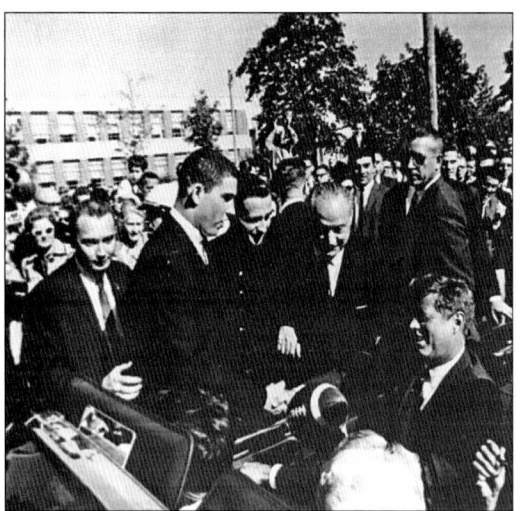

Just two days before the start of the Cuban Missile Crisis in October 1962, Pres. John F. Kennedy had less somber issues on his mind as he stopped at St. Edward High School to visit with the student body on Detroit Road in Lakewood. The school was founded by the Congregation of Holy Cross, the same order that founded the University of Notre Dame. St. Edward is an academic and sports powerhouse, having won more state championships (55) than any other high school in the state of Ohio. TV pioneer Phil Donahue was in the original graduating class of 1953 after attending Our Lady of Angels grade school and before graduating from the University of Notre Dame. (Courtesy of St. Edward High School.)

Jean Donovan (left), a lay missionary, and Sr. Dorothy Kazel, a member of Cleveland's Ursuline Order, were part of the Cleveland Diocese Mission in El Salvador. They served with Maryknoll missionaries Ita Ford and Maura Clarke. On December 2, 1980, they were raped and murdered by members of El Salvador's military. Irish Cleveland is proud to claim Jean Donovan as one of its own. She spent a year in college studying at University College Cork, Ireland, and drew upon her Celtic spirituality as a motivation for missionary service. Sadly, Pres. Ronald Reagan's appointed ambassador suggested that the martyred churchwomen were subversives, and the administration failed to demand accountability on the part of the Salvadoran government. (Courtesy of the Ursuline Sisters of Cleveland.)

This baptismal font stood in St. Columbkille's Church on East Twenty-sixth Street and Superior Avenue for 50 years. After the church was razed in 1957, Archbishop Edward Hoban dedicated a new church and school in Parma in April 1959. The original church was founded by Fr. James O'Reilly and served as the diocesan center for the deaf and hearing impaired. Parish pastor Arthur Gallagher was named diocesan director for the deaf. St. Columbkille was born in County Donegal, Ireland, in the year 521. (CPL.)

Here, Fr. Jim O'Donnell (left) and William Sweeney attend the annual Walks of Life dinner, sponsored by the Irish American Archives Society of Cleveland. Fr. Jim O'Donnell and Sr. Maggie Walsh founded the Little Brothers and Sisters of the Eucharist, an urban ministry of presence, and Bill Sweeney was the last Cleveland councilman of Irish ancestry (to date) to serve the Glenville neighborhood. Bill Sweeney and Father Jim grew up in East Cleveland's St. Philomena's Parish, which was long an Irish stronghold. (Author.)

Pictured here, Joanne Golden Kilbane poses with her classmates at St. Vincent De Paul Parish School, at 134th Street and Lorain Avenue. The Cleveland Diocese considered the school, a part of a large Irish parish founded by Monsignor Flanigan in 1922, a vital part of parish life. A strong emphasis on education served the Irish immigrant community well as it assimilated and grew in respect and influence in the wider Cleveland community. (Author.)

St. Ignatius High School has its origins in the creation of St. Ignatius College, which later became John Carroll University (JCU), in University Heights, Ohio. In 1911, St. Ignatius High School in Ohio City had record attendance as the college and high school celebrated their 25th anniversary. St. Ignatius and JCU are lead by the Society of Jesus (the Jesuits). (Cleveland Memory.)

Three

THE TIES THAT BIND

Perusing 19th-century city directories and contemporary lists of social organizations reveals the wealth of cultural societies that have arisen over two centuries of Irish life in Cleveland. Some groups have had a more political agenda, like the Fenian Brotherhood, while some were established to reinforce moral values, such as the Father Matthew Mutual Benefit and Total Abstinence Society. Others, like the East and West Side American Clubs, offer Irish Americans an opportunity to celebrate their heritage and rejoice in life's special occasions with parties, dinners, and receptions. Many of Cleveland's Irish men and women are members of the Ancient Order of Hibernians, which is the oldest Irish Catholic organization in the United States and keeps friendship, unity, and Christian charity as its watchwords.

In the Irish community, instilling young people with a pride in their heritage begins with a cultural education, and in Cleveland today, there are at least seven schools of Irish dance. The 58th Annual Feis—held in Cleveland in May 2014—saw Irish youngsters vie for honors in Irish dance, voice, and instrumental competitions. Additionally, since 1982, an Irish cultural festival has been held to showcase and preserve the cultural heritage of Ireland through dance, food, exhibits, and musical performances by renowned entertainers. This weekend event also offers Irish Catholics the opportunity to attend an outdoor Mass, said by the Reverend Thomas D. Mahoney and others.

The Irish identity is not always expressed through club membership or musical performance, but through interaction with nature as well. The Irish Cultural Garden was first dedicated in 1933 and has been shepherded by several different organizations, including the Irish Garden Club and the Ladies Ancient Order of Hibernians. The ongoing supervision of this cultural gem resulted in the renovation and enlargement of the garden's northern section and its rededication in 2009.

Just after the Civil War, Cleveland's Irish first walked from church to church in honor of the feast of St. Patrick, on March 17th. This became the inspiration for Cleveland's annual St. Patrick's Day parade—an event deserving of its own book that will soon celebrate its 150th anniversary. The parade is currently organized by the United Irish Societies.

The leaders of one of these societies, Cleveland's Clan na Gael, welcomed IRA chief of staff Sean Russell to a packed Cleveland Convention Center in April 1939. Russell had been detained by the Secret Service in Detroit. When Irish Cleveland congressman Martin L. Sweeney organized a walkout of over 75 congressmen from the official welcome for British king George VI, President Roosevelt acquiesced and let Russell meet with the Irish community in Cleveland.

Irish Cleveland continues to this day to keep warm the ties to the Motherland. These ties that bind include areas such as commerce, education, politics, tourism, arts, family, and sport. The old Irish American and Irish Cleveland tradition of keeping the vision of "One Ireland, One Island, One Nation" moving forward burns bright to this day and will do so until the vision is complete. All of Irish Cleveland's numerous groups and organizations work to keep the Irisher identity alive and well within the Irish American community in Cleveland.

The Keeley Institute, located on Woodland Avenue, was established during the 1890s to provide treatment for drug, alcohol, and opium diseases. Others, like Fr. Theobald Matthew from County Tipperary, thought that the answer to problems with alcohol was the taking of the Total Abstinence Pledge. In 1851, Father Matthew visited Cleveland and preached that the pledge was both remedy and protection. (CPL.)

Here, Kathleen Whitford (left), former president of Cleveland's Irish Northern Aid chapter, is pictured with Martin McGuinness, the deputy leader of Sinn Fein—Ireland's oldest political party. They were attending an event at the Lakewood home of Harry Simon, cofounder of Cleveland's Irish Northern Aid chapter. (Courtesy of Kathleen Whitford.)

Pictured in 1913, these men and women are attending the annual St. Patrick's Day dinner at the Chamber of Commerce Hall. Attendees were members of the Ancient Order of Hibernians and its ladies auxiliary. The name of this Catholic organization comes from the ancient Latin name for Ireland, Hibernia. (CPL.)

Here, the Irish Goodfellows are gathered for their 1913 luncheon in honor of the Feast of St. Patrick. The event was held at the Hollenden Hotel in that year, and the group continues to meet for the feast in downtown Cleveland to this day. (CPL.)

Mary Duffy (right), president of the ladies auxiliary of the Ancient Order of Hibernians, is seen pinning a lovely shamrock corsage on Beatrice Gallagher Lynch (left), who had been named Hibernian Woman of the Year in 1957. The ladies auxiliary was established in 1894 and is a sisterhood of Irish and Irish American Catholic women in partnership with the Ancient Order of Hibernians. (Cleveland Memory.)

The Ancient Order of Hibernians of neighboring Summit County dedicated this memorial honoring American patriots and veterans of Irish heritage. It is located at the Western Reserve National Cemetery, just south of Cleveland, in Medina County. Irish Americans and Irish Clevelanders have served their country in great numbers—and with great distinction— since the American Revolution. The Hibernian Guard of Cleveland was one of the first volunteer units in the country to enlist in the Civil War, and these veterans are honored in Cuyahoga County's Soldiers and Sailors Monument on Public Square. (Author.)

The Irish American Club East Side was established in 1978 by the Irish living on Cleveland's east side. Those gathered around the table are, from left to right, Tim McMahon, board member; Mary C. O'Donnell, secretary; Bonnie McNally; Jerry Quinn, president; and Pat Talty, treasurer. (Cleveland Memory.)

Here, a group of students from the Burke School of Irish Dance are seen performing. Tessie Burke, the founder of the school, has been teaching this traditional form of dance for 50 years. Her father, Tom Scott, came to Cleveland from Ireland with his family in the 1940s, and he is credited as being the first Irish dance teacher in the city. Youngsters are instructed to focus on their feet while keeping their bodies straight and tall. (Cleveland Memory.)

In August 1971, Irish Clevelanders of all ages took to the streets of Cleveland to support the ongoing struggle for human and civil rights in the north of Ireland. This reflected Irish Cleveland's strong leadership and support for a free and independent Ireland that continues to this day. Irish Clevelanders also made their support for basic human rights known when Prince Charles visited Cleveland-Marshall College of Law on October 20, 1977; Cleveland attorney Jack Kilroy was removed from the room for asking the royal to address the ongoing violations of human and civil rights in the six counties. (CPL.)

Seen here during a 1980 performance, these young men and women are dancers from the Bob Masterson Irish School of Dance. Bob Masterson studied dance under the tutelage of Kevin Shanahan, who was teaching in Cleveland in the 1940s. Bob Masterson honored his mentor by forming his own school to instruct young men and women in this rich, traditional form of dance. (Cleveland Memory.)

More than 1,000 young people from Eastern and Midwestern states, as well as Canada, participated in the Fourth Annual Irish Feis Folk Festival, sponsored by the Greater Cleveland Feis Society. The youngsters participated in Irish dancing, vocal and instrumental music, and oratory competitions. The theme of this Feis Folk Festival—held on May 25, 1974—was "Can Ireland Ever be Free." (CPL.)

Folkways Records was dedicated to recording American folk music in all its forms. Several records were cut by some of Irish Cleveland's best artists. In this volume, Frank Barrett, Tommy Burne, Johnny Coyne, Frank Keating, and Tommy McCaffery share the vibrancy of traditional Irish music in Cleveland. This label was taken over by the Smithsonian Institution. These albums and individual tracks can be downloaded at the Smithsonian Folkways website, www.folkways.si.edu. (Author.)

Four Irish dancers are seen here rehearsing for the Irish Feis held in June 1965. In the foreground is Colleen Mangan, age five. Behind her, from left to right, are Peggy Nefords, age 10; Mary Masterson; and Thomas Campbell, age 12. (CPL.)

This brochure announced the 32nd Annual Irish Cultural Festival, held at the Berea Fairgrounds from July 18 to July 20, 2014. The festival featured more than 20 Irish performers; an Irish coffee house that served hot tea, scones, and soda bread; and presentations and workshops focusing on Irish instruments. On Sunday, Fr. Thomas Mahoney said an 11:30 a.m. Mass. Proceeds from the festival were donated to the Holy Family Home, the Make-A-Wish Foundation, and the West Side Catholic Center. John O'Brien and family established the festival, and John—a native of County Roscommon—also serves as the current president of the West Side Irish American Club. (Author.)

These children are rehearsing in their backyard for the Smithsonian Folk Festival in July 1971. The young dancers were led by Al O'Leary, second from the left, on the accordion. Colm O'Leary, third from the left, was a North American step dancing champion. (CPL.)

Although Irish dance is an important aspect of Irish culture, performances by skilled musicians are appreciated as well. These three young flutists performed at the eighth annual Irish Parade Ball, held at the Sheraton Hotel Cleveland. Funds raised from the ball were used to support the 1970 St. Patrick's Day parade. The youthful performers are, from left to right, Mike Hayes, eight; Brian McNamara, nine; and Brendan O'Leary, nine. (CPL.)

Everyone loves a band, and who better to entertain than the Shamrock Pipe Band? Michael Foley of Lakewood and Tony Lavelle from West Ninety-fifth Street were members of this Irish musical group. (CPL.)

Members of the Ladies Ancient Order of Hibernians gather at the Irish Cultural Garden in the fall of 2012 to welcome Enda Kenny, *taoiseach* (prime minister) of Ireland, to Cleveland. Pictured from left to right are Marie Kilbane Leffel, Bonnie McNally, Sheila Murphy Crawford, Donna Leary (over shoulder to left) Teresa Reily Kowalski (next to Kenny), Shannon Corcoran (over shoulder to right), Taoiseach Enda Kenny, Maureen Cavanaugh, Marilyn Madigan, Margaret Lynch, Maire O'Leary Manning, and Patricia Lavelle. (Courtesy of Clevelandpeople.com.)

On December 23, 1929, the St. Augustine Boys Choir served as cheerful carolers as they sang "Hark! The Herald Angels Sing." Mary Finucan stands at her window to hear their angelic voices on a snow-covered evening. (CPL.)

Parmadale Children's Village opened in 1925 as a home for orphaned boys between the ages of 6 and 16. Among its first admissions were the boys from the St. Vincent and St. Louis orphanages, as those institutions were in the process of closing when Parmadale was being constructed. The Children's Village differed from a more traditional institution in that it featured residential cottages. The youths at Parmadale participated in a choir, and some enjoyed performing in an Irish quartet. This group's repertoire was known to include John McCormack's Irish songs. Sr. Winifred (Bridget) Golden, CSA, served as a longtime house parent at Parmadale. (Cleveland Memory.)

Three smiling five-year-olds grasp hands as they pose for this photograph in 1966. They are, from left to right, Eileen Banaghan, Sheamus Mangan, and Mary Agnes Kilbane. (CPL.)

Cultural pride can be expressed through music and dance but also through more lasting memorials. The Irish Cultural Garden was dedicated in 1939, and 70 years later, it was refurbished and renovated—enlarging the northern section and adding a fountain that is a replica of one outside of St. Patrick's Cathedral in Dublin. Here, Rev. E.A. Kirby of St. Cecelia's Church on Kinsman Road is seen planting Killarney rose bushes, sent directly from Ireland, on the occasion of the opening of the Irish Garden. Congressman Martin L. Sweeney (holding hat) from Ohio acted as master of ceremonies. There are 24 gardens in Rockefeller Park, along East and Martin Luther King Jr. Boulevards, and each represents a different ethnic or cultural group. Various Irish authors and poets are memorialized in the garden as well. (Cleveland Memory.)

These charming young women brought enjoyment to all with their dancing at the annual Irish Day Picnic, held at Euclid Beach Park in 1962. They are, from left to right, Shelagh Comer, 16, daughter of Michael and Mary Comer, the longtime host of the *Echoes of Erin Radio Hour*; Maureen Cooney, 16; and Sheila Murphy, 17. (CPL.)

Commodore John Barry was born in County Wexford and is often called the "Father of the American Navy." He went to sea as a child and rose to command the US fleet. In 1960, John Barry Day was celebrated at the Irish Cultural Garden, with Rear Adm. Joseph N. Murphy coming from Philadelphia to pay tribute to Barry. (CPL.)

51

Fr. John Mary Powers, son of Bridget and Thomas, was born in Cleveland in 1876. He was ordained to the priesthood in 1902 and in 1915 became the founding pastor of St. Ann Parish, where he would remain until his death in 1966. As a child, he was athletic and loved biking and baseball, and legend states that Father Powers was the man most responsible for having the Ohio Legislature legalize Sunday baseball games in Cleveland. (Courtesy of Communion of Saints Parish.)

In 1918, a concert was performed at Gray's Armory for the benefit of St Ann's. A sketch of the original church is seen on the front cover of the program. This performance was the inaugural concert of the world-renowned Cleveland Orchestra. Father Powers was the tenor soloist at the concert. (Courtesy of Communion of Saints Parish.)

The Gaelic Athletic Association (GAA) was formed in County Tipperary in the 1800s as a way to promote traditional Irish sports, such as hurling and Gaelic football. While much older than either soccer or rugby, they contains elements of both. Irish Clevelanders brought their love of Ireland's national sports with them and played them with skill and vigor. The Cleveland Shamrocks played at Shamrock Field, which is now sometimes called Herman Park, in the Detroit-Shoreway neighborhood. Today, St. Pat's and St. Jarlath's are the only two active clubs. John O'Brien Sr. and the late Sean Gannon were longtime leaders of Gaelic games in Cleveland, and Mark Owens—a native of County Derry—led the effort to bring the North American GAA Championship games to Cleveland in 2013. (Courtesy of Hugh Gallagher.)

In 1894, James "Lynch" Lynchehaun—seen here in a police sketch—allegedly set fire to the Achill Island home of his English landlord and beat the landlady. Lynch fled Achill and escaped to relatives in Cleveland, where he reportedly operated a pub near West Twenty-eighth Street and Detroit Road—on the edge of the Angle. Lynch is noteworthy in that he was the basis for Christy Mahon in famed Irish playwright John Millington Synge's *Playboy of the Western World*. Lynchehaun's actions eventually landed him before the US Supreme Court regarding an extradition request from the United Kingdom for him. If Lynch's actions were viewed as political rather than criminal in nature, it would preclude his extradition. (Author.)

Irish cultural accomplishments also extended to professional journalism, and Anne O'Hare McCormick began her career in Cleveland, Ohio, where she served as an associate editor for the *Catholic Universe Bulletin*. She later became a foreign correspondent for the *New York Times* and became the first woman to join its editorial board. McCormick was the first woman to received a major-category Pulitzer Prize (1937). Additionally, Cleveland's own Mary Jordan, a writer for the *Washington Post*, was awarded a Pulitzer for international reporting in 2003 for her work on conditions in Mexican jails. Jordan's family is from Ballycroy. (Cleveland Memory.)

Two other art forms often associated with Irish culture are literature and theater. This artist's sketch, "Oscar Wilde and the 'Science of the Beautiful,'" appeared on the front page of the *Plain Dealer* on February 18, 1882—the day that Wilde arrived in Cleveland for a lecture. At the time, Cleveland newspapers rarely published illustrations, thus revealing the stir around Wilde's tour. (CPL.)

Vincent Dowling, Irish actor and director, was the artistic and producing director of the Great Lakes Shakespeare Festival from 1976 to 1984. The festival was a summer repertory theater that staged its performances at the Lakewood Civic Auditorium. Here, busy patrons of the arts are seen enjoying conversation outside of the auditorium. Dowling was also a member of the famed Abbey Theatre Company. (Cleveland Memory.)

The group who gathered for this 1893 photograph are members of the Irish German Society. The Irish and Germans, the two largest ethnic groups in Cleveland, frequently intermarried and gathered to celebrate their common bonds. (Cleveland Memory.)

Grace McGinty represented the United States in an international junior dance championship held in Ireland in August 1928. McGinty returned from the contest with three medals. The lovely lass is seen here in costume, striking a dancer's pose. (CPL.)

Here, the Fife, Drum, and Bagpipe Corps from the West Side Irish American Club (WSIA) stand at ease in their formation. The club was organized in 1931 and provided a social center that fostered interest in Irish history and culture. The WSIA has undoubtedly been one of the most dominant and influential of the Irish Cleveland groups for many decades. (Cleveland Memory.)

Four

On St. Patrick's Day, Everyone Is Irish

New York City is often credited for holding the first St. Patrick's Day parade, followed by Savannah, Georgia; Montreal, Canada; and Chicago, Illinois. Cleveland's first St. Patrick's Day celebration occurred shortly after the end of the Civil War and was likely organized by the Ancient Order of Hibernians. Featuring music and dancing, it was attended by large numbers of Irish observers on Cleveland's west side. The event grew larger over the years—as did its audience—and the Hibernian Riflemen and Irish Tradesmen later assumed responsibility for the parade's planning and execution. In 1910, state senator Dan Mooney introduced a bill to recognize St. Patrick's Day in Ohio, and 1912 saw hundreds of thousands of attendees at Cleveland's parade. Many were surely in attendance to welcome Cleveland's own: boxer Johnny Kilbane, who had recently won the world featherweight championship.

War and hard times prevented the parade from being held in downtown Cleveland between 1913 and 1935, though other, less elaborate festivities took place on the city's west side. Over the next 20 years, the Irish Civic Association took charge of the annual event as it increased in size and visibility. Since 1935, an individual who has made significant contributions to Irish activities in Cleveland has been named the grand marshal, and, beginning in 1963, a woman who has done credit to the "Irish Nationality" has been honored as Mother of the Year. In 2001, Lonnie McCauley was the first woman to be named grand marshal. Lonnie was the first archivist for the Irish American Archives Society and researched much of this parade history. Tragically, Lonnie was unable to march in the 2001 parade, as she died of cancer on March 18, 2001.

By 1957, a collective of eight individual Irish groups had come together to form the United Irish Societies. Tasked with the singular mission of planning, organizing, and raising funds for the parade, this nucleus was later joined by additional groups, including the Ancient Order of Hibernians, the Celtic Athletic Foundation, the Cleveland Ceili Club, the Cleveland Comhaltas, the Cleveland Gaelic Society, the Cleveland Pioneers Total Abstinence Association of the Sacred Heart, Forever Young, the Greater Cleveland Feis Society, the Greater Cleveland Police Emerald Society, the Irish American Archives Society, the Irish Civil Association, the Irish Cultural Festival, the Irish Northern Aid Committee, the Irish Public Affairs Council, Irish Summerfest, the Ladies Ancient Order of Hibernians, the Mayo Society of Greater Cleveland, the McNeely Library Foundation, the Murphy Irish Arts Association, the Padraic Pearse Center, the Retired/Retireable Irish Police Society, St. Jarlath's Gaelic Football Club, the Shamrock Club, the West Side Irish American Club, and the East Side Irish American Club.

The parade currently begins at East Eighteenth Street and Superior Avenue, stepping off shortly after 1:00 p.m. The parade consists of marching units, bands, floats, drill teams, and dignitaries who walk the parade route. Also marching are police, firefighters, political figures, and those who serve the community in other ways. In 2014, hundreds of thousands attended the event, despite chilly temperatures.

2014 Saint Patrick's Day Parade

Cleveland's 147th Parade
Irish Entertainers of Stage and Screen

The 147th St. Patrick's Day parade was held on March 17, 2014. The grand marshal was Andrew Dever—a native of Polranny, County Mayo—and the parade cochairs were author John O'Brien Jr. and the Gaelic Athletic Association's Mark Owens, a native of Derry. The Mother of the Year honor was given to Bridie Joyce, originally from County Galway. The line of march began with the lead units, followed by three divisions of participants representing clubs, educational institutions, firefighters, police, local unions, area notables, and organizations too numerous to mention. (Courtesy of United Irish Societies.)

Marchers throughout the years have been many and varied. Pictured in 1960, these children rode in a donkey cart that was led by another youngster who walked the parade route. (CPL.)

Men in top hats and tails have participated in many St. Patrick's Day parades. This group is seen walking down Euclid Avenue in 1952. A sign for Rosenblum's Department Store is also visible. (CPL.)

59

The high hats were on the march again in the 1953 parade. This time, the gentlemen were photographed passing the Sterling Lindner Department Store, which is perhaps best known for the magnificent Christmas tree put on display to attract shoppers in the month of December. (CPL.)

This photograph provides a detailed view of the high hats as they march in the 1935 parade. Many are seen tapping their canes, while others tip their hats and wish everyone top of the morning. (Cleveland Memory.)

Young men from Parmadale were known not only for their voices but also for their instrumental proficiency. In the 1954 parade, the high hats were preceded by the Parmadale band, seen here as it passes East Ninth Street. (CPL.)

For many years, the parade route took marchers down East Ninth Street, past the reviewing stand and St. John's Cathedral. Here, the Tricolor and American flags lead the way as hundreds of onlookers line the streets on March 17, 1935. Windows can be seen, their curtains open so that those inside can catch a glimpse of the festivities. (Cleveland Memory.)

In 1986, these observers from Euclid, Ohio, wore buttons claiming they were a natural Irish family. This photograph of the Nugent family includes, from left to right, Kevin, age six; mother Patricia; Michael, age eight and Kathleen, age 12. Patricia was celebrating her birthday on St. Patrick's Day. (CPL.)

These majorettes braved snow flurries on the day of the parade. Appearing a bit windblown, these girls were members of the Carol Koonts Majorette Troupe of Canton, Ohio. From left to right, they are Lyvonne Gardner, Paula Gibson, Linda Gaff, Irene Rowan, and Barbara Norris. (Cleveland Memory.)

Here, the members of Cleveland's Irish Northern Aid Committee proudly hold a banner that proclaims, "If you want peace—work for justice," calling for peace and justice in the northern six counties of Ireland. Pictured are Kathleen Whitford to the left, Erin Randall, and Roger Weist on the right. (Author.)

Dancing in the street is permissible on St. Patrick's Day, and here, a costumed couple joins hands for the festive occasion. They appear oblivious to the warmly dressed crowds on what must have been a cold March 17, 1939. (Cleveland Memory.)

A warm cup of Irish coffee may have been a welcome beverage, but this sizeable mug was used as a parade float in 1980. An unidentified man and woman peer over the rim of the cup to wave to the assembled crowd. (Cleveland Memory.)

This smiling group of women from the West Side Irish American Club (WSIA) drill team has assembled in a shamrock pattern during a rehearsal for the 1961 parade. The drill team—which had practiced since the beginning of January—was led by Carole McGinty and planned to take part in a preview parade at the second clubhouse of the WSIA, running from West Ninety-eighth Street to Madison Avenue and then to West Sixty-fifth Street, where Mass was held at St. Colman's Church. (Cleveland Memory.)

Here, Fr. William J. Murphy, dean of men at John Carroll University, has prepared to march through the streets of Cleveland, bearing a shillelagh adorned by a green bow. This year, 1953, marked Father Murphy's 20th anniversary of walking the parade route in all kinds of weather, and he could not be persuaded to ride in any conveyance. (Cleveland Memory.)

Mrs. Arthur Carey of Rocky River, Ohio, took pride in her son Tom, dressed here in a jacket with a shamrock lapel and a fine top hat. Tom, with arms akimbo, seemed pleased with his appearance as he prepared to celebrate St. Patrick's Day in 1957. (Cleveland Memory.)

Everyone loves a leprechaun, especially at the parade. Here Jimmy Myers celebrates his Irish heritage from Counties Tipperary, Mayo, and Kerry by dressing the part. (Cleveland Memory.)

James E. McCoy and Mary McDonald from Cleveland's east side are seen here dressed in Irish dance costumes. It is not clear whether this couple was planning to be part of the 1929 St. Patrick's Day parade, but they would have been a lovely addition to the annual celebration. (Cleveland Memory.)

Those in public service are always part of the parade. Pictured here, from left to right, are Capt. Kevin Kilbane of the Cleveland Police Department; Judge Mary Eileen Kilbane, Court of Appeals; and Lt. John Kilbane of the Cleveland Fire Department. These siblings honor the strong Irish American and Irish Cleveland tradition of public service. (Author.)

The parade is often a family affair, and pictured are, from left to right, cousins Seamus Kilbane, Kara Kilbane, Joanna Kilbane Myers, Grace Kilbane, Andrea Kilbane, and Tess Kilbane Myers holding Liam Kilbane as they prepare to march with the West Side Irish American Club Junior Fife and Drum Corps. (Author.)

St. Patrick's Day is even honored at the White House. Pres. Barack and Michelle Obama issued this invitation for a reception to welcome the taoiseach (prime minister) and other Irish leaders. In fact, President Obama's great-great-great-grandfather was born in the village of Moneygall in County Offaly, Ireland. (Author.)

Five

THOSE WHO SERVE

During the rough and ready days of Whiskey Island, Cleveland's elite viewed Irish lads as the source of less than legal activity in their growing community, and it has been suggested that the city's elite saw recruiting these Irish ruffians for the police force as a useful tool for restoring peace and order. In 1874, while the Irish comprised 10 percent of Cleveland's population, they represented 20 percent of the police force. By the turn of the century, the Irish still represented 12 percent of the city's police. Fire was another threat to the safety of the citizenry, and the Irish also joined the ranks of those who fought to subdue the frequent blazes in a city still largely built of wooden structures. Regardless of the department, the Irish—who usually spoke English—happily took advantage of this public sector employment and saw it as an opportunity to serve their newfound home.

But not all Irish sought to serve by ensuring the public's safety, choosing instead to advance society's welfare by seeking public office. Unlike other cities, Irish Clevelanders did not establish large political machines but legislated alongside members of other ethnic groups in the chambers of Cleveland City Council, with Irish candidates consistently representing certain Cleveland wards. Over the years, Irish political figures have held—at one time or another—every prominent position in the city and county governments. Mercedes Cotner was clerk of council for 25 years, beginning in 1963, and Margaret McCaffery served on the city council for 28 years—under six different mayoral administrations. Irish Democrat "Honest" John Farley was mayor of Cleveland from 1883 to 1884 and 1899 to 1900, and Cleveland law director Thomas A. Burke was elected mayor in 1945—serving for four terms. County government has seen several Irish Americans elected to the role of county commissioner, including Mary O. Boyle, Ed Feighan, Tim Hagan, Timothy McCormack, and Robert Emmett Sweeney. Irish men and women of bench and bar have also been elected to preside over the civil and criminal justice systems in Cuyahoga County, and other Irish public leaders, like Martin L. Sweeney, Jim Stanton, Michael and Edward Feighan, Dennis John Patrick Kucinich, and David Joyce have advanced to play a role on the national level by serving in the US Congress. The Cleveland judiciary has been dominated by the Irish names of Sweeney, Gallagher, McMonagle, Kilbane, Kilcoyne, Corrigan, Talty, Spellacy, Gaughan, Gravens, Carroll, Gaul, Carney, O'Donnell, McConnell, Cooney, Keough, Gorman, McManamon, Gilligan, and many others.

This 1910 photograph provides an inside look at a fire station as the men prepare to fight a fire. They are seen here in a hurry to dress and reach their battle stations. (CPL.)

The Cleveland Fire Department's No. 18 Engine House was located at 3400 Orange Avenue. Constructed in 1898, the station was reportedly designed by Henry Delaney, chief of the 2nd Battalion. Delaney's love of horses is certainly reflected in the figures at the upper front of the building. (CPL.)

These firemen, outfitted in protective gear, pose with their engine after having just extinguished a fire. (CPL.)

Three readily recognizable white horses draw the No. 2 engine as it dashes down Superior Avenue near East Ninth Street. One man holds the reins, while another stands at the rear of the engine. (CPL.)

Seated on a bench is Jack McDonald, captain of the Euclid Beach Police Department. Euclid Beach was a popular amusement park on Lake Shore Boulevard on Cleveland's east side. The park entertained visitors young and old from the 1890s to 1969. (Cleveland Memory.)

Inspector Tim Costello of the Cleveland Police Department was buried from St. Ignatius Roman Catholic Church, on West Boulevard and Lorain Road. Hundreds attended the funeral to pay their last respects. (Cleveland Memory.)

Judge George McMonagle poses with two children from St. Joseph's Orphanage as they enjoy ice cream. The three are attending Irish Day at Euclid Beach Park, as illustrated by the tags the girls wear. W.R. Ryan, who served as Cuyahoga County sheriff, founded Euclid Beach Park in the 1890s. (Cleveland Memory.)

Judge Martin A. Foran served as a judge in the Cuyahoga County Common Pleas Court from 1911 to 1921, as county prosecutor from 1875 to 1877, and as a representative in the US Congress from 1883 to 1889. Judge Foran started his career as the head of the Coopers International Union and was an early supporter of reform mayor Tom L. Johnson. Judge Foran also fought in the Civil War, lived for two years in Ireland, and is buried in Cleveland's Lake View Cemetery. He was the first Catholic admitted to the Union Club and was a strong advocate of Irish nationalism. (Cleveland Memory.)

Residence of late Sen. M. A. Hanna, Cleveland.

Marcus Alonzo Hanna, businessman and US senator, was also a friend and political manager of Pres. William McKinley. Hanna, born in Lisbon, Ohio, was descended from Thomas Hanna and Elizabeth Henderson Hanna and had roots in Ireland. (Cleveland Memory.)

Although not an officeholder, Lucia McBride, the debutante daughter of Lucia McCurdy and Malcolm Lee McBride, would surely have been a phenomenon in the political arena if she had followed her mother's example. Mrs. McBride was active in the League of Women Voters and the National Woman Suffrage Association. (Cleveland Memory.)

Margaret McCaffery was a member of Cleveland City Council for 28 years, and Pres. John F. Kennedy once described her as one of the most influential politicians in the country. In this photograph, she is standing next to John Carson, a poll worker. (Cleveland Memory.)

Mercedes Cotner was an elected member of the city council and later became the first woman to serve as clerk of the city council, holding that position from 1964 until she retired in 1990. She was the longest-serving individual to hold that title in the city. (Cleveland Memory.)

Martin L. Sweeney held many leadership roles in Irish Cleveland. Sweeney served as a judge in the Cleveland Municipal Court for many years and also as the national president of the Ancient Order of Hibernians, the largest Irish organization in the United States. Sweeney also represented Cleveland in the US House of Representatives from 1931 to 1943 and was a delegate to the 1932 Democratic Convention, where he was instrumental in helping FDR win his first nomination. Before entering public service, Sweeney attended St. Bridget's school and worked on Cleveland's docks as a longshoreman. (Courtesy of the Robert E. Sweeney family.)

Kathleen Kennedy Townsend, Maryland lieutenant governor and daughter of Sen. Robert and Ethel Kennedy, visited Cleveland on many occasions. In the fall of 2008, she visited Magnificat High School in Rocky River, founded by the Humility of Mary Sisters, to speak to an all-school assembly about public service. After her meeting with students, she visited the West Park Cleveland Police and Fire Memorial to lay a wreath in honor of those who have served the public and paid the ultimate measure, many of them Irish Clevelanders. Leading Kennedy Townsend was West Park resident Grace Leon (left), widow of Cleveland policeman Wayne Leon, who was killed in the line of duty on June 25, 2000. (Author.)

Cleveland mayor Thomas A. Burke joined other mayors as they called on Pres. Harry S. Truman in 1946. In the front row, from left to right, are Mayor Burke, President Truman, and Edward J. Kelley of Chicago, Illinois. The Burke Lakefront Airport was named after this mayor for his support of its creation. Burke was an Army veteran and attended the College of the Holy Cross and the Western Reserve University Law School. (Cleveland Memory.)

Robert Emmett Sweeney (left) is pictured here with Gerry Adams, president of the Irish political party Sinn Fein. Sweeney was national director of the Ancient Order of Hibernians, a member of Clan na Gael, and represented a dozen major national Irish groups at the DNC Platform Committee hearings in 1992. This resulted in one of the first Ireland planks in a national party platform. Sweeney was an unparalleled trial attorney and was instrumental in establishing legal liability against national asbestos manufacturers. Sweeney was also Cuyahoga County commissioner, where he led the efforts to purchase the State and Ohio Theaters and save them from the wrecking ball, and a member of the remarkable "Great Society" 89th Congress, which fashioned Medicare, the Voting Rights Act, and other pieces of landmark legislation. (Courtesy of the Robert E. Sweeney family.)

John J. Carney poses with his family in this photograph, taken during his run for re-election as the Cuyahoga County auditor. From left to right are John's sons Jimmy and Jody; wife Virginia; John; son Johnny; and daughter Jeanne. Rascal the dog is seated on Jeanne's lap. Carney served as common pleas judge and is the brother of James Carney, mayorial candidate and real estate developer. (Cleveland Memory.)

Six

Upstairs, Downstairs

New opportunities were on the horizon as Cleveland's economy became driven by the iron and steel industries, and Irish laborers found work in many companies owned by their brothers from the Old Sod. Anthony Carlin and David Champion became innovators in the business of manufacturing rivets, and James Clary served as secretary-treasurer of the Bourne-Fuller Company, just one of the steel companies that later merged to become Republic Steel. M.F. Barrett was taught the molder's trade and eventually established Cleveland Brass Manufacturing, incorporated in 1912. James W. Corrigan and partner Price McKinney would create a major steel company located strategically on the Cuyahoga, which proved a valuable asset for Republic Steel when it acquired the firm in 1935.

Yet, for all of this, Irish businesses produced products other than iron and steel. Stephen C. Creadon and John T. Feighan formed the Standard Brewing Co. and created a beer, Erin Brew, that reflected their Irish heritage and continues to do so today. The Hyland family, also with roots in Ireland, founded the Hyland Software Company, and Chris Connor currently serves as president of international business giant Sherwin Williams. Ford Motor Company has employed thousands of Irish Clevelanders, and they might be surprised to learn that Henry Ford's father was born in Cork, Ireland.

Duncan and Margaret McFarland emigrated from Ireland in 1843. They worked their way to the Euclid Creek area in what is today the border of Cleveland Heights and South Euclid, where the native bluestone, a fine, desirable form of sandstone, provided economic opportunity for the McFarlands and many other Irish immigrant families. The bluestone quarry mining started shortly after the Civil War and continued through the World War I period and created the roots for many east side Irish families.

The growth of industry proved to be a double-edged sword, as it offered employment to many but paid its workers unsatisfactory wages for long hours in plants and factories. The labor movement had its roots in the early 19th century, when skilled workers first established unions, and by 1882, the groundwork was laid for the formation of the American Federation of Labor. Cleveland's Irish were heavily involved in the labor movement, and men like Edward F. Murphy and Patrick O'Malley would eventually assume positions of leadership within it. In 1955, the founding convention of the newly merged AFL and the CIO was held at the Cleveland Convention Center.

This lithograph of a pencil sketch shows a boat taking on a load of coal. Many of the workers engaged in that work were Irish. (CPL.)

It is equally certain that some of the men repairing the wooden schooner in this 1910 photograph were Irish as well. Many sons of Erin found work in shipbuilding and repair, contributing to Cleveland's commercial success through their labor on the docks. (CPL.)

A large number of boats were placed in dry dock on the Cuyahoga River during the winter months. This 1870 photograph shows the river crowded with the vessels awaiting the spring thaw. The significance of river, canal, and lake commerce to Cleveland's growth and the Irish community cannot be overstated. (CPL.)

From the decks of this boat, docked on the Cuyahoga River in 1864, one could look up Cleveland's Superior Avenue. In the background, horses and wagons are visible, as are the buildings and businesses that lined Superior Avenue. The boat was built by T.W. Kennard. (CPL.)

This photograph shows the Cuyahoga River, looking south from the Main Street Bridge. A sign in the background advertises the McWatters-Dolan Co., an Irish Cleveland business that specialized in clothing, hats, and furnishings. Their slogan was, "If we please you, tell others. If we don't, tell us." (CPL.)

Early machinery for unloading ore is on display on the docks. The equipment assuredly assisted dockworkers in the 1890s as they performed their jobs. (CPL.)

Moving inland from the docks, the Irish also found employment at the Cleveland Rolling Mill in the old Newburgh neighborhood. Newburgh was once bigger than the city of Cleveland. The smoke bellowing forth in this 1890 photograph is a sign of good economic times. For the Irish living in Newburgh, the area was far removed from Cleveland, and in earlier years, travel involved a two-hour horse-and-buggy ride. (CPL.)

This is the Corrigan-McKinney Steel Company as it appeared in 1924. James W. Corrigan died in 1928, and Republic Steel acquired the company in 1935. At one time, over 8,000 men worked at this Newburgh mill. Corrigan's father, Capt. James W., started the company with a fortune made with Standard Oil. (CPL.)

In 1937, Cleveland was confronted by the Little Steel strike, which began in May and ended in August. At Republic Steel's Corrigan-McKinney plant, there was violence between replacement workers inside the plant and those on strike outside. Here, workers are seen returning to their jobs following the strike. (CPL.)

United Auto Workers Local 45 also took action against management in 1937, beginning with a sit-down strike at the Fisher Body Plant that shut down production. As a result of the strike, General Motors accepted the union as the workers' bargaining agent. Although not employed by Fisher Body, Patrick O'Malley—from County Mayo—was a dynamic leader for United Auto Workers and AFL-CIO. In this image, striking autoworkers are assembling outside the plant on East 140th Street and Coit Road. (Cleveland Memory.)

The Fisher Body Plant strike was generally nonviolent, although on the night of the sit-down strike, picketers kept a train intended to transport the auto bodies made in the plant that day from departing. This photograph reflects an angry response from autoworkers at the plant, this time during the 1939 strike, where efforts were made to overturn an automobile as a policeman with a nightstick attempted to stem the action. (Cleveland Memory.)

Before the automobile became king, street cars were common. In 1899, over 850 employees of the Great Consolidated Line of the Cleveland Electric Railway launched a strike. They demanded better wages and working conditions, as well as union recognition. Rioting and violence broke out throughout the city that summer, and Mayor "Honest" John Farley had to call upon the state militia to help Cleveland's police maintain order. Here milling crowds throng the streets, stopping traffic. (CPL.)

St. Malachi's Church
West 25th and Detroit

THE ANGLE SONG
(Tune: Galway Bay)

Did you ever go across the bridge to Pearl Street?
Did you ever dance at Bott's Academy?
Did you ever buy a fish at Patsy Boland's?
Did you ever pray in Old St. Malachi's?

For the breezes blowin' up from Whiskey Island
Were perfumed by the Gas House as they blew.
And the women in the kitchens cooking corned beef.
Spoke a language that the stranger never knew.

Oh—the city came and took away our homesteads.
They pushed us out beyond Edgewater Park.
Sure they tried to take the Irish from the Angle.
But they'll never take the Angle from our hearts.

Courtesy of
Lillie Collins

The Angle represents "ground zero" for the Irish in Cleveland. The early Irish mostly arrived on boats, moving from work on the Erie Canal, which terminated at Lake Erie at Buffalo, and continuing on to Cleveland to start the Ohio Canal. They lived and worked for decades on the banks of the lake, river, and canal, not just building the canal but doing the longer-standing work related to the shipment of goods from the Ohio heartland back to the large Eastern markets that were at the other end of the Erie Canal and the return of manufactured goods. Later, the oil and steel industries needed the water for their processes and to transport the necessary raw materials and finished product. The Angle and the Flats swampland were rejected by other new arrivals to Cleveland and left to the Irish to call home. (Author.)

This panoramic view of the Cuyahoga River features three-masted schooners loaded with ore. The schooners are being unloaded by dockworkers—many of whom were Irish—in the early 1880s. (CPL.)

The *Kelley Island*, which bore the name of the Cleveland settler and "father" of the Ohio and Erie Canal, Alfred Kelley, is seen delivering a load of sand to the Cleveland Builders Supply Company's docks. This 200-foot boat was owned by the Kelley Island Lime and Transport Company. (CPL.)

87

The Great Lakes Brewing Company was founded in 1988 by brothers Dan and Pat Conway. They single-handedly created the Midwest's handcrafted brew industry and rebuilt Cleveland's brewing legacy. These St. Edward High School graduates built their restaurant, brewery, and pub in Ohio City. Great Lakes has won many gold medals and strongly adheres to a business philosophy of environmental sustainability. (Author.)

The Standard Brewing Company was established in 1904 by Stephen S. Creadon and John T. Feighan. In this 1927 photograph, the company's horse and wagon pose in a residential Cleveland area. On the wagon is a motto that reads "Erin Brew, Ehren Brau." The latter portion can be translated as "Ireland Forever." (CPL.)

Great Lakes Brewing makes multiple brews, lagers, and ales. One is Conway's Irish Ale—the label for which is pictured here, on the side of the brewery. It features Irish Cleveland policeman Patrick Conway directing traffic in front of St. Malachi Parish, at West Twenty-fifth Street and Detroit Avenue—near the brewery's location. Officer Conway is the grandfather of Great Lakes Brewery founders Pat and Dan Conway. Their parents, John and Margaret Collins Conway, grew up in St. Colman Parish. Margaret Conway worked with famed Safety Director Eliot Ness. (Author.)

Frank O'Malley was a west side butcher who operated a meat market on Detroit Avenue. His grandparents were the first to settle in the Old Angle, and O'Malley continued to serve its residents for 38 years. He commented that, as the years passed, the Irish continued to patronize his shop to purchase their corned beef and cabbage, though they now had to travel further—coming from Avon, Lakewood, Rocky River, and Sheffield. (Cleveland Memory.)

89

John P. Murphy was an attorney who graduated from the University of Notre Dame and came to Cleveland to work for the Van Swerigen Brothers real estate empire. He ended up owning and running the Higbee Department Store. Later, Murphy served on Notre Dame's Board of Trustees and helped cement the long-standing tie between Irish Cleveland and Notre Dame. Murphy used his resources secured in commerce to create the Murphy Foundation to advance education and other worthy causes. The John P. Murphy Endowed Chair at Notre Dame Law School was donated by Murphy. Cleveland is blessed to have two Murphy foundations. The Murlan Murphy Foundation was created by the Murphy Oil Soap family company, founded here in Cleveland. The Murlan Murphy Foundation also focuses on education and other charitable causes. (Cleveland Memory.)

The long and vital relationship between Irish Clevelanders and organized labor is well represented in Patrick O'Malley, a native of County Mayo who started his work in this country at White Motor Corporation. Part of the effort in 1932 when the CIO organized White Motor, Pat rose up the ranks to become both regional director of UAW and the president of the Cleveland Federation of Labor for over a dozen years through 1970. This dual leadership role made him one of Cleveland's most powerful labor leaders. Patrick was grand marshal of the 1959 St. Patrick's Day parade and was an ardent Irish nationalist. Irish Cleveland's Martin Hughes of the Communication Workers of America was another strong president of the Cleveland Federation. Irish continued in this important federation leadership role to present days, including John Ryan, also of the Communication Workers of America. (CPL.)

This beautiful home—located at 7200 Detroit Road—was built as a wedding present from Irish immigrant Patrick Smith for his son Louis Patrick Smith. Patrick Smith had made his fortune through towing and dredging on Lake Erie. Louis's wife was heiress to the Farnan Brass Works and another Irish Cleveland millionaire. In the 1940s, the home was purchased by Daniel Berry, who moved his Berry Funeral Home into the location. Daniel's sons, Dan and Roger, continued the family business, and a third generation of Berrys continues today in Westlake. Pictured is the Craciun Berry Funeral Home. (Author.)

Agnes B. and William F. Chambers established their funeral home on Cleveland's west side, first on West Eighty-fifth Street and Madison Avenue, and then—since 1937—at its current location on Rocky River Drive, across the street from St. Patrick's (West Park) Roman Catholic Church. The home has remained family owned and operated and has served Greater Cleveland and Northeastern Ohio since 1933. Two additional homes are now located in Berea and North Olmsted, Ohio. (Author.)

Mark McGorray was an Irish immigrant who arrived in the United States in 1844 and settled in Cleveland in 1864. He opened his funeral home in 1873 in Cleveland's Ohio City, and in 1922, it was moved to Lakewood, Ohio. Now known as McGorray-Hanna, the home has an additional location in Westlake, Ohio. Mary Susan McGorray and Gil Hanna are its current directors. (Author.)

The Schulte-Mahon-Murphy Funeral Home, pictured here on Mayfield Road in Lyndhurst is the modern incarnation of a number of Irish American family businesses in the funeral industry. It was created by the merging of several Irish Cleveland family businesses, all of which reached back several generations, and it continues to serve members of the community in the eastern suburbs. Many other Irish Cleveland funeral homes have, or continue, to serve in this way, such as Mahon-Melbourne, McMahon-Coyne, and Corrigan. (Author.)

John D. Rockefeller, once the world's richest man, moved to the Cleveland area in 1853 and attended Central High School. He organized Standard Oil and, by 1880, was worth $18 million. Although he later moved most of his business empire to New York for tax reasons, Rockefeller's loyalty remained with Cleveland, and both he and his wife are buried at Lake View Cemetery. Rockefeller's middle name, Davison, was his mother's maiden name and represented his link to Ireland. Long before "30 Rock," Cleveland had its own Rockefeller Building, at West Sixth Street and Superior Avenue. (Author.)

The unfair treatment of Irish workers encouraged Edward F. Murphy to join Teamsters Local No. 4 when it was established in 1911. Murphy was once a horse cart driver—where he had experienced low wages and long hours—and was important to the Cleveland Federation of Labor. (Cleveland Memory.)

93

James E. O'Meara was an advocate for teachers and held leadership positions in the Cleveland Teachers Union, the Ohio Federation of Teachers, and the American Federation of Teachers. He also active on behalf of civil rights groups and served on the Civil Rights Committee of the Cleveland AFL-CIO, the Ohio Civil Rights Commission, and other organizations. (Cleveland Memory.)

The Irish American Caucus is a lobbying group that was established by Fr. Sean McManus in September 1974 at a meeting of the Ancient Order of Hibernians. It was created at a time when Northern Ireland was gripped by violence and it was deemed necessary to provide a counter to British influence in the US Congress. Seen here at the Irish National Caucus Cleveland Chapter gathering in 1979 are, from left to right, chairman of the Cleveland Chapter Terry Joyce, of Laborers Local 310; Frank Gaul, Cuyahoga County treasurer; Congressman Mario Biaggi, head of the Friends of Ireland Caucus in the House of Representatives; Fr. Sean McManus; and Judge John V. Patton, of the Ohio Eighth District Court of Appeals. (Cleveland Memory.)

The East Ohio Gas Explosion, one of Cleveland's worst disasters, occurred when a tank of natural gas exploded in 1944. Here, gas company employees George Spicer, Pat Joyce, Mike McGinty, and Pat Malloy connect a steam pipe running to liquid tanks. (Cleveland Memory.)

While Irish Clevelanders were loyal Americans, their hearts went out to those in their homeland who suffered under British oppression. Cleveland has been, and continues to be, at the forefront of fighting for justice and peace across all of Ireland. Here, fervent pleas for assistance were posted on St. Thomas Aquinas—encouraging the purchase of bonds to "Lift Ireland Up" and promising that giving to Ireland was "lending to liberty." Observers were also told that every bond purchased would help. (Diocese.)

95

Many Irish Americans joined the Fenian Brotherhood with the hope of supporting related organizations in Ireland as they attempted to force the United Kingdom into negotiations for the establishment of an Irish Republic. In June 1866, following the end of the American Civil War, a plan was devised for an invasion of Canada to be led by Col. John O'Neill—a former Union cavalry officer—and featuring Gen. T.W. Sweeney and an army of 500 Irish American volunteers. It was thought that, with Britain distracted by a Canadian invasion, conditions would be favorable for an uprising in Ireland or to negotiate for Irish freedom. The Battle of Ridgeway was fought at Fort Erie, Canada, across the Niagara River from Buffalo. (Author.)

There was a Cleveland connection to the Battle of Ridgeway, as Colonel O'Neill was to mobilize his Fenian Regiment and other forces, and the men were to travel to Cleveland by train while disguised as railway workers. They arrived on May 28, 1866, only to learn that there were no boats to carry them to Canada. They were sheltered overnight in warehouses on the Cleveland waterfront and then traveled to Buffalo by train. The Fenians would have arrived and departed through Union Depot—the second railway depot in Cleveland—which was built in 1866 near the site of the first depot and at the foot of the hill where Bank (West Sixth) and Water (West Ninth) Streets met the lakeshore. (Cleveland Memory.)

Seven

Sports Reign in Cleveland

Historically, some Irish have spent their lives laboring in the world of manufacturing, while others preferred to perform on the gridiron, the diamond, or in the ring. Lebron James, Corey Kluber, and "Johnny Football" Manziel have made Cleveland the center of the sports universe in 2014, but, while these modern athletes are not Irish, sports in Cleveland would not be the same without the contributions of men named Carroll, Dunn, Kilbane, McBride, O'Donnell, Dolan, Sweeney, and O'Neill.

Historians have suggested that boxing was the first sport to offer immigrants a golden opportunity for wealth and recognition. Whether this is true or not, the "sweet science" called to Jackie Keough, the 1947 welter weight champion, and John Patrick "Johnny" Kilbane, from Cleveland's near west side. Johnny was trained by boxer Jimmy Dunn, and, while his mentor would work with other fighters, none would achieve Kilbane's level of fame. In 1912, Johnny Kilbane defeated Abe Attell to become the world featherweight champion—a title he would hold until 1923.

Alfred Carroll was known as the godfather of Greater Cleveland wrestling and would serve for 50 years as the secretary of Greater Cleveland Wrestling Coaches and Officials. He was dedicated to improving the sport for its youthful participants.

Another Dunn also played role in Cleveland Sports when Chicago businessman "Sunny" Jim Dunn purchased the Cleveland Indians. The team's ballpark was dubbed Dunn Field and only resumed it former name, League Park, after Dunn's death. The O'Neill family name also become linked with the Cleveland franchise when a group of investors—including Frank J. O'Neill—bought the Indians from William Daley and Ignatius O'Shaugnessy. Although the team was later sold to another business conglomerate, ownership was transferred to Francis O'Neill by the mid-1970s. O'Neill often used the name "Steve" in honor of Steve O'Neill—a catcher and manager for the Indians. Today, the Tribe is owned by the Dolan family, proud members of the Cleveland Irish community.

Football has often vied with the boys of summer, however, and the Cleveland Browns were organized by Arthur "Mickey" McBride and Roger Gries in 1945. Years earlier, Jimmy O'Donnell—sports promoter and owner of the Cleveland Tigers professional football team— helped to create the American Professional Football Association, which is better known today as the National Football League. Ed Sweeney, a Cleveland plumbing businessman, started the Cleveland Pipers, members of the National Industrial Basketball League, and with general manager Mike Cleary named John McLendon the first African American manager in professional basketball. The team was later sold to George Steinbrenner in 1961.

In 1977, Jimmy Goggins (left)—then president of the Cleveland Gaelic Athletic Association—posed with Eddie Campbell—past president of the West Side Irish American Club (WSIA)—to show off a recent GAA trophy in front of the West Side Irish American Club, then located at West Ninety-eighth Street and Madison Avenue. The GAA played a significant role in the Irish Revival at the turn of the 20th century by fostering a strong Irish cultural identity, which laid a solid foundation for Irish independence. (Cleveland Memory.)

Brian Dowling is an outstanding athlete and a member of the Greater Cleveland Sports Hall of Fame. In six years of high school and college football, he lost only one game. He was the quarterback at both St Ignatius (1963) and Yale University. At Yale, he was a classmate of Gary Trudeau and was the inspiration for the iconic *Doonesbury* comic strip character B.D., short for Brian Dowling, with his ever-present football helmet. B.D. also had a brief career in the NFL. (Courtesy of St. Ignatius High School.)

In 1917, Rose McDonnell, a sister-in-law of Johnny Kilbane, married James Patton. The Patton family included a Thomas who would later become president of Republic Steel. Members of the McDonnell, Kilbane, and Patton families are seen here on Rose McDonnell's wedding day, posing in front of Johnny Kilbane's home at 7413 Herman Avenue in St. Colman's Parish. (Courtesy of the Weist family.)

Jackie Keough epitomized Irish Cleveland's passion for the sport of boxing. Jackie perfected his skills in the ring at the Old Angle Gym next to St. Malachi's Church. He was twice the Cleveland Golden Gloves champion and the national Amateur Athletic Union welterweight champion in 1947. Keough was a World War II vet and spent his career as a tug boat captain with Great Lakes Dredge and Dock Company. Keough served as a judge in the 1975 Muhammad Ali–Chuck Wepner title bout held at the Richfield Coliseum (Wepner was the inspiration for *Rocky*). Jackie and his wife, Peg, raised their seven children in Lakewood, Ohio. (Courtesy of the Keough family.)

To maintain his featherweight title for 11 years, Johnny had to continue his training. In this photograph, Johnny has assumed his fighting stance and is shown delivering a right hand uppercut. (Cleveland Memory.)

During World War I, Johnny became a lieutenant in the US Army and was assigned to Camp Sherman, near Chillicothe, Ohio, where he trained the men in self-defense. Seen here are, from left to right, (first row) Mike Gibbons, Tom Gibbons, and Johnny Griffiths; (second row) Johnny Coulton, Johnny Kilbane, Benny Leonard, Billy Rodenbach, and Bob McCusker. Many of these men held boxing titles. (Cleveland Memory.)

James Francis Aloysius O'Malley Jr. was born in 1915 with a daily racing form in his cradle and was known to all as "Junior" O'Malley. Horse racing is known as "the sport of kings," but the Irish, both in Ireland and Cleveland, know it better than any king. Junior grew up on the west side of Cleveland and worked at the *Plain Dealer* as a typesetter and also at Thistledown Race Track as a mutuel clerk. Junior's passion for the ponies was legendary, and his life was part of the vibrant cast of colorful characters that make up the Irish Cleveland community. (Cleveland Memory.)

In this iconic photograph of the boxer, Johnny Kilbane is seen here seated in his corner of the ring. His look of happiness and self-assurance is priceless. (Cleveland Memory.)

This sculpture, *Johnny Kilbane: Fighting Heart*, stands in Battery Park on Cleveland's near west side. It was created by renowned Dublin sculptor Rowan Gillespie and features three statues of Johnny—as a boy, as a boxing champion, and as clerk of courts. The statues came to Cleveland by ship and were installed on Irish limestone pedestals by the sculptor. The site is near the Herman Avenue address that Kilbane called home when he had his first title fight. (Author.)

Sporting events other than boxing also attracted Irish Clevelanders' attention in the first part of the 20th century. Here, the Cleveland National Air Races are enjoyed by a group of women and a male companion, their eyes on the skies and their parasols shielding them from the sun. From left to right are Mary Gallagher, Mrs. Neil Devine, Mercedes Hurley, and William J. McManns. (Cleveland Memory.)

In 1929, Gladys Livingstone Berry O'Donnell (left) became the first licensed woman pilot in the Air Derby. She is seen here presenting actress Ann Harding (right), also adept at flying, with a ticket to the National Air Races in Cleveland—to be held August 27 to September 5, 1932. O'Donnell won the Aerol Trophy during the 1932 races. The women who flew in that race demonstrated great courage—taking off into an approaching thunderstorm that hit the Cleveland Airport during the third lap. These woman aviators also found a champion in Nancy Corrigan, a native of County Mayo who came to Cleveland in 1929 and taught herself to be a pilot. This pioneer aviatrix, who had her first solo flight at age 19, also taught her male counterparts at a flight academy during World War II. (Cleveland Memory.)

League Park was known as Dunn Field from 1916 to 1927, when it was named for Cleveland Indians owner "Sunny" Jim Dunn, from Chicago. The team won the 1920 World Series in this ballpark, defeating the Brooklyn Dodgers. (CPL.)

The Irish brought their love of horses to America. Here in Central Park, Jimmy Campbell, native of Ballycroy, County Mayo, shows his horse and carriage to his Irish Cleveland family and friends, Pete Campbell and Terry Joyce (seated) and Tom Campbell and Pat Campbell (all of Laborers Local 310). Jimmy owned the horse stables in Manhattan that served the entire horse carriage trade in New York City. He was legendary for hosting the many Irish travelling between Cleveland and Ireland. Pete Leneghan, who operates the horse carriage trade in Cleveland, learned his skills working with Jimmy for many years in New York City. See www.shamrockcarriages.com. (Courtesy of the Leneghan family.)

The Cleveland Indians had their first World Series victory in 28 years when they defeated the Boston Braves in 1948. A valuable member of this championship Indians team was catcher Jim Hegan. He is seen here in a Detroit locker room with his teammates in July 1948. They are, from left to right, Dale Mitchell, Bob Lemon, and Jim Hegan. Hegan's son Mike was also a professional baseball player and later provided color commentary for the Indians games. (Cleveland Memory.)

Samuel Edward Thomas McDowell was a pitcher who played in the major leagues for 15 years and spent 11 years with the Cleveland Indians. He ended his career with an overall 3.17 ERA and had 2,453 strikeouts. He was nicknamed "Sudden Sam" for the left-handed fastball that he delivered with an unusually calm pitching motion. (Cleveland Memory.)

Frank Ryan was the quarterback who led the Cleveland Browns to a victory over the Baltimore Colts in 1964, bringing the team its last National Football League title. Ryan threw three touchdown passes to Gary Collins, the game's MVP. He is also known for being the only player in the league to hold a PhD in mathematics. Ryan taught at Case Western Reserve University in Cleveland and at Yale University. (Cleveland Memory.)

Arthur "Mickey" McBride founded the Cleveland Browns and, during his tenure as owner from 1944 to 1954, the team won five league championships. McBride was also a real estate developer and owned taxicab companies in Cleveland. (Cleveland Memory.)

Here, NFL great Jim Brown (left) is greeted by the greatest fan in professional sports—Irish Clevelander John "Big Dawg" Thompson. Big Dawg created the identity of the Dawg Pound and symbolizes the enthusiasm of Irish Cleveland's passion for sports. His mother, Mary Gallagher Thompson, was a native of Dooega, on Achill Island in County Mayo. For a time, John lived with family in Strabane and Claremorris, Ireland. John Adams, the Indians super fan of banging drum fame, is also of Irish descent. (Courtesy of John Thompson.)

Eight
NIGHTLIFE AND THE NOTORIOUS

When asked to discuss prominent criminals and cases in Cleveland, residents will assuredly speak of the exploits of Danny Greene, the sensational trial of Sam Sheppard, and the horrific Torso Murders. The casual observer is often unaware of the links between these events and the Irish community, and far fewer have knowledge of the Irish gangs that terrorized Cleveland's near west side during the late 19th and early 20th centuries. As many Irish moved out of their traditional neighborhoods and headed further west, they brought a lawless reputation with them that often manifested in gang activity. Teenagers and young adults in the McCart Street Gang participated in petty theft and vicious assaults—a heritage that they may have passed on to the Cheyennes. The Cheyennes were allegedly based on West Sixty-seventh Street, north of Detroit Avenue and outside of the city's West Sixty-fifth Street boundary. The leader of the Blinky Morgan Gang, Charles Conklin, was hanged for the murder of Cleveland detective William Hulligan in 1888.

While the Thompson sub-machine gun (the Tommy gun) is often associated with organized crime, the first Tommy guns were manufactured in Cleveland by Warner and Swasey for the Colt Firearms Company. John Fortune Ryan, a member of Clan na Gael, arranged for the first Cleveland Tommy guns to be sent clandestinely to Michael Collins in Ireland.

Between 1935 and 1938, a serial killer brutally murdered 12 victims in the Cleveland area. Despite his best efforts, Cleveland's safety director Eliot Ness was unable to bring this killer to justice. Several Irish law enforcement agents were involved in the investigation of these heinous crimes. They included Sheriff Martin L. O'Donnell, Deputy Michael Kilbane, Detective James Hogan, and Lt. Pat O'Brien of East Cleveland.

The weekend of July 4, 1954, saw the announcement of the murder of Marilyn Reese Sheppard, wife of Dr. Sam Sheppard, in her own home. Suspicion immediately fell upon Dr. Sheppard, and several people involved in his prosecution and defense were Irish. John Mahon served as prosecutor, and Bill Corrigan was Sheppard's defense attorney. In the second Sheppard trial, John T. Corrigan led the prosecution with assistant prosecutor Leo Spellacy—the brother of Judge Margaret Spellacy.

The 2011 film *Kill the Irishman* tells the story of Daniel John Patrick "Danny" Greene, the Cleveland longshoreman president, labor organizer, and alleged racketeer who was killed in a car bombing in 1977 during a bitter fight over the control over Cleveland's "off book" businesses. Greene was proud of his Irish heritage and often carried off acts of kindness, helping neighbors in need and creating the image of a modern Robin Hood.

The Irish pub is much more than a mere saloon. It is a place to find physical and spiritual sustenance, a home away from home where all ages are comfortable, a place for coming together to share a story and maybe a song, a place to debate and fight, a place of deep sadness and great happiness, a place to love and laugh. An Irish pub is not just mercantile real estate, it is fully engaged and alive. Irish Cleveland has been blessed with many a pub, and it is impossible to name all or even remember all.

A group of first- and second-generation Irish youths formed the McCart Gang, perhaps named for McCart Street (now West Sixty-ninth Street), where the members lived at some point. In 1891, members of the gang were brought to Common Pleas Court judge Alfred Lamson's courtroom, at the Cuyahoga County Court House in the northwest area of Public Square, where they were charged with robbing a saloon on Alger Avenue in West Cleveland. This structure was the third Cuyahoga County Court House, built in 1858. (CPL.)

Cuyahoga County prosecutor Frank T. Cullitan and Cleveland mayor Thomas Burke look at the spoils of a police raid at the Harvard Club, the largest gambling operation between New York and Chicago. Located on Harvard Road, just outside the city limits in the village of Newburgh Heights, the Harvard Club was operated by Irish Clevelander James "Shimmy" Patton and Daniel T. Gallagher. At other raids, Shimmy told police that "anyone that goes in there gets his goddamned head blown off." This threat often worked to discourage a completed raid, as the club could hold up to 1,000 patrons. (CPL.)

In July 1954, the news that Marilyn Sheppard, the wife of Dr. Sam Sheppard, had been brutally murdered in her Bay Village home rocked the Cleveland community. Today, the debate continues as to whether Dr. Sheppard was her killer, or whether a bushy-haired intruder committed the crime. This image provides a bird's eye view of the courtroom during Sheppard's trial. The defense team—seated on the left side of the table—included Sam Sheppard's father Richard, Deputy Sheriff James Kilroy, Bill Corrigan, and Sam Sheppard. The prosecution—seen on the right side of the table—is, seated from front to back, John Mahon, Saul Danaceau, and Thomas Parrino. Sheppard's famous defense attorney, Bill Corrigan, established the Corrigan name in the public eye. (Cleveland Memory.)

Vonnie Kilbane stands with her mother, Mary O'Boyle Campbell, and her two children, Maryann Kilbane Gerity and Tom Kilbane, in front of the family café, Kilbane's Tavern, at Franklin Circle in Ohio City. (Courtesy of the Kilbane family.)

Thomas "Nit" Kilbane offers refreshment at Kilbane's Cozy Corner. The hospitality business was a common entrepreneurial activity in the Irish community. Kilbane's was located at Franklin Circle (West Twenty-eighth Street and Franklin Boulevard) just south of the Angle, near the present-day Lutheran Hospital. (Courtesy of John Eugene Kilbane.)

Danny Greene was Cleveland-born but was conscious of the Irish ancestry that could be traced through both parents. Danny was the president of the longshoreman's union, a labor organizer, and a reputed part of Cleveland's racketeering community. Greene lost his life in a car bombing in 1977, the culmination of his battle with the members of Cleveland's Italian and Jewish communities who controlled organized crime locally and were frustrated by Greene constantly escaping their efforts to eliminate him. Here, Greene (right) consults with noted Cleveland attorney John Butler. Butler is noted for his Shakespearean eloquence, and the local criminal defense bar honors an attorney each year with the John Butler Lifetime Achievement Award for Excellence in Criminal Trial Work. (Cleveland Memory.)

One notable man stood on the right side of the law, and that was John T. Corrigan. The son of Irish immigrants, Corrigan lost an eye and some hearing during the Battle of the Bulge, in World War II, and later served as a state senator. He was elected county prosecutor in 1956, at the age of 33, and served in that office for a record 35 years. He died in 2003. The strong Irish presence in the Cuyahoga prosecutor's office continues with the current county prosecutor, Timothy J. McGinty. (Cleveland Memory.)

Pubs have always been an integral part of the communities they serve, and one such pub found a home in Cleveland Heights on Noble Road. Tim Ryan's Pub offered the neighborhood good food, great conversation, and wonderful entertainment. Ryan and his wife, Gretta, served as its proprietors from 1978 to 1982 and hosted the best in Irish music between New York and Chicago. (Courtesy of Tim and Gretta Ryan.)

111

Karen O'Malley, proprietor, welcomes customers to the Harp restaurant. The Harp immediately became an Ohio City landmark when the O'Malley family opened this house of hospitality with a panoramic view of Lake Erie and downtown Cleveland, including Whiskey Island and much of the Angle. It is a regular home to the Porter Sharks and other great Cleveland Irish musical groups. Inside there is a beautiful mural depicting the view from Mike O'Malley's home in Dooega, Achill, County Mayo, overlooking Clew Bay. Ireland is the only nation to have a musical instrument, the harp, as its national symbol. (Author.)

Located on Center Street, the Flat Iron Café has been serving Clevelanders since 1910. Its name is either derived from the shape of the building or its similarity to the Flat Iron Building in New York City. Diners have many selections to choose from, and part of the menu is written in Gaelic. It lives up to its title as an Irish restaurant and bar. It is described as Cleveland's oldest Irish pub and is the regular meeting site of the United Irish Societies during the planning of the annual St. Patrick's Day parade. It is situated across from the Irish Heritage Site and the Great Hunger Memorial, which is on the banks of the Cuyahoga River. (Author.)

Night Town—a pub, fine restaurant, and popular musical venue—opened in 1965 and is named for Dublin's red light district in James Joyce's *Ulysses*. The current owner, Brendan Ring, is from County Kerry and arrived in Cleveland in 1991. Always a popular venue, Night Town is the place to be on St. Patrick's Day, with plenty of corned beef, Guinness, and Irish music by the New Barleycorn. It is also the place to observe Bloomsday every June 16th, which is celebrated by public readings of *Ulysses*. The signature dish at Night Town is the Dublin lawyer. (Author.)

For many decades, Pat Joyce's Tavern was the best-known Irish restaurant and pub in Cleveland. Located first on East Ninth Street near the celebrated Short Vincent Street, the restaurant later had locations on Chester Commons, on East Sixth Street, and in Rocky River at Rockcliff Springs. Pat Joyce's family is from County Mayo. (CPL.)

Here, from left to right, Winifred Joyce, Ray Kelly, and Tommy McIntyre pose at the Colonial Boy, on West 112th Street and Lorain Avenue. The bar was part of the Irish hospitality scene on Cleveland's west side. (Cleveland Memory.)

Moriarty's Pub has been a place to enjoy good beer and great conversation since the 1930s. Located on East Sixth Street in downtown Cleveland, the pub is currently owned by Morgan Cavanaugh. Prior to that, the John Feighan family owned it for 50 years. Groups such as the Chieftains have been known to have informal sessions here after their performances downtown. (Author.)

Stone Mad, located in the once solidly Irish Detroit Shoreway area, is a pub and restaurant that is located in a 100-year-old storefront on West Sixty-fifth Street. Proprietor Pete Leneghan spent three years restoring the building before opening the pub in 2008. The interior includes a walnut bar and a lounge where Eileen Sammon greets her guests. Sinn Fein's Gerry Adams celebrated his 60th birthday at Stone Mad with his Cleveland supporters and friends. (Author.)

P.J. McIntyre's is a newer addition to the west side hospitality scene. Located in the Kamm's Corners neighborhood, it is operated by Patrick and Rebecca Campbell—both alumni of Michael Flatly's *Lord of the Dance*—and cousin Tom Leneghan. The Leneghan and Campbell families hail from Ballycroy, County Mayo. Its beautiful interior and turf fire transport one to Ireland. (Author.)

The Public House is an anchor of the Kamm's Corner neighborhood—part of Cleveland's West Park community. West Park took its name from John M. West, of Leitrim, Ireland. West arrived in the United States in 1826, settled first in Euclid Township, and then moved west to Rockport Hamlet around 1842. There, he purchased a 600-acre farm on Lorain Road. A lake was created on the 25 acres between his home and the street, with rowboats and picnic grounds. This came to be known as West's Park, and the name was eventually applied to the entire community. (Author.)

The Pride of Erin, located at West 123rd Street and Lorain Avenue and formerly known as the "123," was opened by John Campbell and partner Bartley Leneghan, both natives of Ballycroy, County Mayo. Campbell was one of the founders of the Cleveland chapter of Irish Northern Aid. he was also one of the cofounders of Irish Northern Aid in Cleveland and grand marshal of the parade in 2008. (Author.)

Nine
Irish Ambassadors

Over the years, Cleveland has received visits from individuals as diverse as George Burns and Gracie Allen, Charles Dickens, Walt Disney, and Abraham Lincoln. World-famous actors and musicians have graced local stages, and outstanding athletes have played at the city's sports venues. In 1964, for example, the Beatles entertained thousands of screaming fans, and John, Paul, and George each had an Irish grandparent. At the same time, Cleveland's Irish have been welcoming guests from their homeland, embracing new Clevelanders as their own, and cherishing visits from other prominent Irish Americans for over 160 years. In turn, the Irish community has sent out ambassadors of its own to entertain and edify. Irish Cleveland is proud of Fr. Thomas Gallagher, who in 1965 flew with Martin Luther King Jr. from Cleveland to Selma, Alabama, and joined in the march to Montgomery, the state capital.

Fr. Theobald Matthew, an Irish Capuchin, came to Cleveland in 1851 to advocate on behalf of the Total Abstinence Society. In 1867, John DeVoy of Clan na Gael spoke to the Fenian Convention in Cleveland. The year 1880 witnessed the visit of Charles Stewart Parnell, the "uncrowned King of Ireland," an Irish member of Parliament, and a land reformer. Even Irish literary figure Oscar Wilde stopped in Cleveland in 1882 during his lecture tour of the United States.

Political leaders have visited as well. Eamon de Valera, prime minister and president of the Irish Republic, first came to Cleveland in 1919 to speak at the Cleveland City Club. In the mid-1990s, Sinn Fein leaders Gerry Adams and Martin McGuinness visited during the lead-up to the Good Friday Accord. Finally, in 2012, the Irish community welcomed Prime Minister Enda Kenny to the Mayo Society Ball.

The Irish community has also given the world a group of remarkable authors and performers. One can point to the comedy of actor Tim Conway, or the success of Drew Carey—whose television program was set in his beloved Cleveland. Phil Donahue, a member of St. Edward High School's first graduating class, was the host of his own talk show, and Irish transplant Mike Douglas became a singer and television host. The lengthy list of other Cleveland exports includes the likes of Jack Hanrahan, Declan Joyce, Ken Lynch, Maeve McGuire, Halle Berry, Erin O'Brien, John O'Brien, Jack Riley, Joe Garry, Rory O'Malley, brothers Michael and Matthew Rego of the Kelly family, *Saturday Night Live*'s Molly Shannon, and NBC journalist Kelly O'Donnell.

Little Ann Marie FitzGerald visits the Oval Office with her parents, Jim and Mary Ellen FitzGerald of Cleveland, Ohio. "Ri" was Miss Christmas Seal 1962 and travelled to the White house to meet with Jacqueline Kennedy, the honorary chair of the Anti-Tuberculosis Christmas Seal Campaign, but they had to manage with her substitute, Pres. John Fitzgerald Kennedy. Ri is holding a charm bracelet Mrs. Kennedy acquired for her, and Ri brought PT-109 tie clasps to her brothers back home in Cleveland. The Cleveland FitzGeralds shared common FitzGerald family ancestral stories with President Kennedy, the grandson of Boston mayor John Francis "Honey Fitz" Fitzgerald. (Author.)

The Mike Douglas show premiered on television station KYW and aired from 1961 to 1964. Douglas served as moderator and vocalist, bringing the gift of his voice to a program that included interviews and weekly guest hosts, like Irish performer Carmel Quinn. This photograph shows Douglas with actress Jayne Mansfield, appearing as honorary guests at the Fenn College homecoming in 1963. (Cleveland Memory.)

Tim Russert, although not a native Clevelander, attended John Carroll University in University Heights, Ohio, where he was president of the Student Union. He graduated with a bachelor's of arts in political science and received his law degree from Cleveland-Marshall College of Law in 1976. He also served on Sen. Daniel Moynihan's staff. Russert was moderator of NBC's *Meet the Press* and chief of the NBC News Washington Bureau at the time of his death in 2008. (Cleveland Memory.)

James W. Corrigan (of Corrigan McKinney Steel) married international debutante Laura Mae Whitlock MacMartin in 1917. After her husband died in 1928, Laura lived in Europe, and during World War II, she worked on the behalf of French soldiers and refugees. After the war, she received the Croix de Guerre and the Croix de Combattant, among other honors. (Cleveland Memory.)

Among the many activists for Northern Ireland who came to Cleveland over the years, Bernadette Devlin McAliskey is one of the most well known. Here, she visits with James Colman McCoy, longtime publisher of the *Ohio Irish Bulletin* and a strong supporter of Irish nationalism. She participated in the Battle of the Bogside, stood witness to Bloody Sunday, was shot seven times by Ulster Freedom Fighters in front of her children, was an ardent feminist, and is the youngest woman ever elected to the British Parliament. (Courtesy of Kathleen Whitford.)

Alexander Winton was born in Scotland but came to Cleveland at the age of 22. He formed the Winton Bicycle Company and made his first motorized vehicle in 1896. The next year, he organized the Winton Motor Carriage Company. Winton is seen here at the 1903 Gordon Bennett Trophy Race in Ath, Ireland, behind the wheel of his Winton Bullet 2. The crowd seems impressed by Winton's vehicle. Today, the Winton Place Condominiums sit on the site of his lakefront mansion in Lakewood. (Cleveland Memory.)

Irish Clevelander Sean Gannon, a native of Newport, County Mayo, served as president of the North American County Board of the Gaelic Athletic Association and also organized a Peace and Justice for Ireland Forum in Cleveland. He is pictured here in the summer of 1994 presenting tens of thousands of petitions for peace in the north of Ireland to President Clinton's assistant national security advisor, Nancy Soederberg, in the West Wing of the White House. Sean's congressman, the Honorable Louis Stokes, arranged and attended the West Wing meeting. Also in attendance were Ohio Ancient Order of Hibernians president Roger Weist and Ohio MacBride Principles Campaign leader Owen McGuiness. (Author.)

This photograph shows the birthplace of Ernest Roland Ball at 1541 East Thirtieth Street. Ball was a singer and songwriter who is most famous for writing the music to "When Irish Eyes Are Smiling." He also wrote other famous Irish American songs, like "Mother Macree" and "A Little Bit of Heaven." His life story was told in the film *Irish Eyes Are Smiling*, starring Dick Haymes and June Haver. (Author.)

Irish author Tim Pat Coogan called Eamon de Valera (left) "the man who was Ireland." Dev's first trip to Cleveland was to address the Cleveland City Club as the president of Sinn Fein in 1919, not long after escaping the British firing squad as a result of his leadership role in the 1916 Easter uprising. Here Dev is pictured in 1927 with Cleveland city manager W.R. Hopkins, who presented him with a key to the city. (CPL.)

Archibald MacNeal Willard, an Irish American artist, was born in the Cleveland suburb of Bedford, Ohio. A Civil War veteran, Willard frequently painted scenes based on his wartime experiences. Willard is perhaps best remembered for his iconic *Spirit of '76*, which he claimed was inspired by a parade that passed through the Wellington, Ohio, town square. An original *Spirit of '76* hangs in Cleveland City Hall. (Author.)

Here, Mayor Jane Campbell stands with Steve Mulloy in front of an Achill tourism banner. In 2003, Mayor Campbell led a delegation from Cleveland to Achill, where the island was made a sister city of Cleveland. Steve Mulloy, a native of Achill, spearheaded the effort to formalize the relationship between these two locations that share so much history. Mulloy was a member of Laborers Local 310 and was an active leader in the West Side Irish American Club and Irish Cleveland in general. Mayor Campbell, Irish herself, was a true friend to Irish Cleveland and went the extra mile by travelling to Achill to strengthen the ties between County Mayo and Cleveland. (Author.)

This was the home of Patrick and Margaret Golden, who raised 13 children on the island of Inish Gowla in Clew Bay, County Mayo. Remarkably, most of the 13 Golden offspring left Ireland to make their homes in Cleveland, where many of their grandchildren and great-grandchildren live today. (Courtesy of the Golden family.)

Many Clevelanders travel to Ireland to get closer to their Irish roots. Here, family visits Dooega, Achill Island, and the homestead of Mike and Mary Gallagher Kilbane overlooking Clew Bay. (Author.)

Some Irish families never came to the United States but were important to Irish Americans living in Cleveland. This family portrait, dated 1935, shows Martin and Bridget Moran (née Calvey) and their children Mary, four years old, Coletta, five years of age, and Jack, seated on Bridget's lap, who was 18 months old. This photograph was discovered in 1980, sent as a postcard, and identified by a visiting Calvey granddaughter. (Courtesy of Peggy Calvey Patton.)

At Cleveland's Irish Heritage Site (IHS) stands the Great Hunger Memorial on the banks of the Cuyahoga next to the start of the Ohio Erie Canal. It was erected by the Irish American community and dedicated to both those who died during the Great Hunger (also known as the Irish Famine or the Potato Famine) and the others who lived to enrich Lake Erie's shores. The stone sculpture design was the inspiration of master stone carver and Irish Clevelander Eamon Darcy—a native of Newry, Ireland—while the bas-relief was done by Cleveland artist Paula Blackman, who has Celtic roots from Scotland. (Author.)

Eugene "Pete" O'Grady introduces Sen. Robert Kennedy, who was in Cleveland campaigning for the Ohio Democratic ticket in 1966. Pete moved his wife and 12 children to Columbus after successfully engineering John Gilligan's 1970 election as governor to serve in his cabinet. O'Grady served as legendary chairman of the Ohio Democratic Party. Fellow Irish Clevelander Robert Bennett served as legendary chairman of the Ohio Republican Party for almost 20 years. While "Pete" was his nickname, "Pearse" was his middle name, given by his father after his friend Irish patriot Padraic Pearse. (Courtesy of the Pete O'Grady family.)

John F. Kennedy smiles as he speaks to a large and receptive crowd at a 1960 campaign rally in Cleveland. Although he failed to garner Ohio's 25 electoral votes, Kennedy was elected president in November of that year. (Cleveland Memory.)

Another Irish American president, William Jefferson Clinton, visited Cleveland and stopped into Kathleen's Kitchen, on Lorain Avenue in Kamm's Corner. The woman standing next to President Clinton is Mary O. Boyle, county commissioner and the first woman to be elected to a non-judicial countywide post. Boyle, whose parents were from Ballycroy, was running for the US Senate at the time. Here, Tom Roche and President Clinton are seen discussing the finer points of the ultimate Irish golf course—Bally Bunion—which both had recently visited. Kathleen Finerty and daughter Kathleen operated this favorite local eatery for many years. (Author.)

DISCOVER THOUSANDS OF LOCAL HISTORY BOOKS FEATURING MILLIONS OF VINTAGE IMAGES

Arcadia Publishing, the leading local history publisher in the United States, is committed to making history accessible and meaningful through publishing books that celebrate and preserve the heritage of America's people and places.

Find more books like this at
www.arcadiapublishing.com

Search for your hometown history, your old stomping grounds, and even your favorite sports team.

Consistent with our mission to preserve history on a local level, this book was printed in South Carolina on American-made paper and manufactured entirely in the United States. Products carrying the accredited Forest Stewardship Council (FSC) label are printed on 100 percent FSC-certified paper.

MADE IN THE USA